GATESHEAD
IN
50
BUILDINGS

ROB KIRKUP

AMBERLEY

In memory of John

First published 2018

Amberley Publishing, The Hill, Stroud
Gloucestershire gl5 4EP

www.amberley-books.com

British Library Cataloguing in Publication Data.
A catalogue record for this book is available from the British Library.

ISBN 978 1 4456 6652 5 (print)
ISBN 978 1 4456 6653 2 (ebook)

Origination by Amberley Publishing.
Printed in Great Britain.

Contents

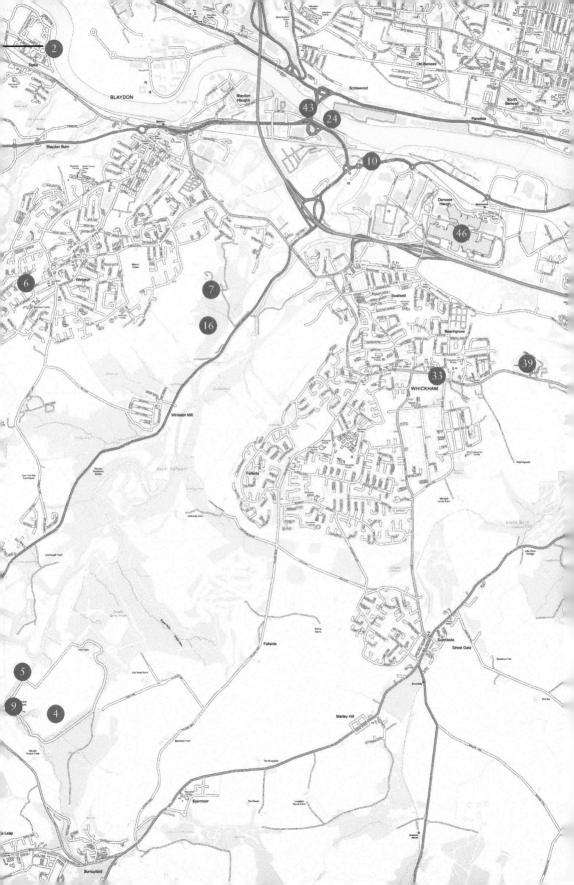

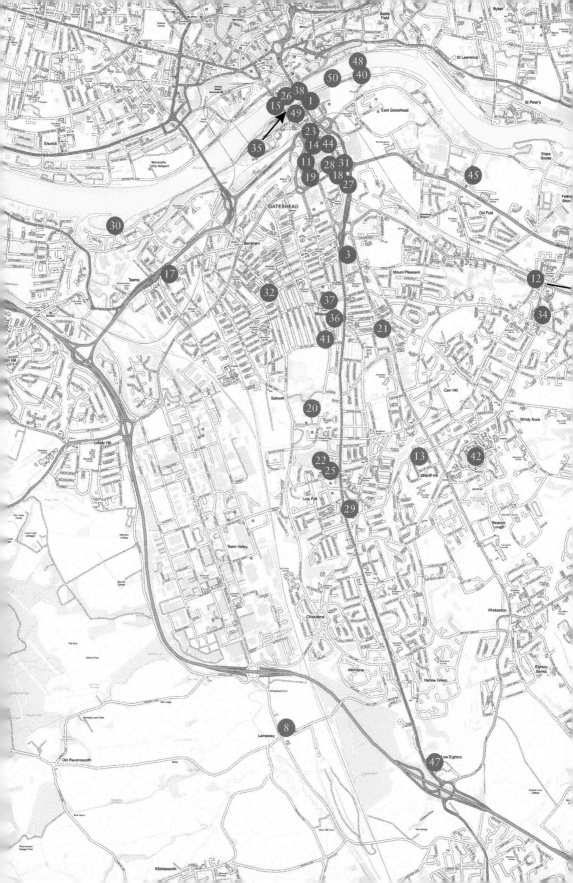

Key

Introduction

The origins of Gateshead are unclear. The earliest archaeological evidence proves that there was a Roman settlement here at the Gateshead side of the present Swing Bridge dating from between the second and early fourth century. Historians speculate that this settlement most likely consisted of a row of shops and temples lining the Roman road, capitalising on the trade offered by passing soldiers.

In the year AD 653 the Venerable Bede wrote of a monastery overlooking the bridge across the Tyne, belonging to an abbot called Utta, as being on a site in 'Ad Caprae Caput'. Translated from Latin this means 'Goat's Head'. It has been debated for many years as to whether Bede was writing of Gateshead, but there is evidence to back up that this was the case. There have been suggestions that Gateshead of the day was home to wild goats. Another justifications for the name is that there may have been the emblem of a goat's head on the Gateshead side of the Roman bridge. We will likely never know, but what we do know is that eleventh-century English Chronicler Symeon of Durham, in *History of the*

Gateshead has long been associated with the sign of the goat.

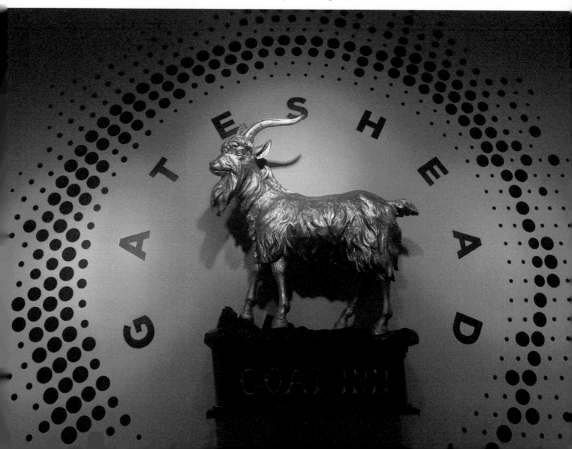

Church of Durham and *Historia Regum* (*History of the Kings*), called Saxon Gateshead 'Ad Caput Caprae'.

Despite the town's unclear association to the goat, the symbol of the goat's head has become synonymous with Gateshead and was incorporated into the town's coat of arms. There have been various iterations of this over the years until 1974, when the Metropolitan Borough of Gateshead was formed.

Novelist and playwright J. B. Priestley wrote of Gateshead in his bestselling 1934 travelogue *English Journey*, 'If there is any town of like size on the continent of Europe than can show a similar lack of civic dignity and all the evidence of urban civilization, I should like to know its name and quality. No true civilization could have produced such a town, which is nothing better than a huge dingy dormitory.' He added, 'The whole town appeared to have been carefully planned by an enemy of the human race. Insects can do better than this.'

Gateshead in 2018 is unrecognisable to the Gateshead that J. B. Priestley was so damning of. Gateshead in 1934 was filled with the sights and smells of the coal staiths, flour mills, chemical works, roperies, and even a fat-rendering plant, and that was just the places that lined the River Tyne.

Gateshead has been transformed in the decades since, to the extent that in June 2011 Google ran a competition to find Britain's best streets, and with over 20,000 votes cast, South Shore Road on Gateshead's Quays was named Britain's Hippest Street. This award is testament to the work Gateshead Council has undertaken to develop the town, with a view to achieving city status. City status was applied for in 2012 as part of the Queen's jubilee celebrations, but the bid failed.

The most notable transformation so far has occurred on the Quays, with the Millennium Bridge, the Sage Gateshead, and the Baltic Centre for Contemporary Art all being constructed since we entered the millennium. They combine to make the Gateshead Quay a truly awesome sight, but work has taken place right across the town to bring Gateshead into the twenty-first century.

In *Gateshead in 50 Buildings* we will explore Gateshead's historical and architectural heritage, with buildings dating from as far back as the twelfth century, through to buildings constructed in the new millennium.

All photographs were taken by the author unless otherwise stated.

The 50 Buildings

1. St Mary's Church, Gateshead

St Mary's Church is a riverside landmark high above the River Tyne and was the only Anglican church in the town until St John's was built in 1825 at Sheriff Hill. This led to it being considered the 'mother church' of Gateshead, and it was the only place that marriages could be officially performed.

It is unknown exactly when the church was originally built, although historians suggest the building dates back to the 1100s, built on the site of a previous church that had been completely destroyed by fire in 1080.

John Hodgson, a local historian, has speculated that some of the oldest stones resemble the Roman style and could have been reclaimed from the remains of a nearby Roman building. There is archaeological evidence that the church stands on a site which could have once been the site of a Roman monastery.

During its 900-year history the church's existence has been threatened on many occasions. During the English Civil War, Parliamentary soldiers were stationed at the church's rectory, and this led to the rectory being destroyed, and the church damaged by cannon balls. St Mary's was damaged during the Great Fire of 1854. A substantial amount of property on both sides of the Tyne was also destroyed and fifty-three people lost their lives. By 1979, the building, which was no longer being used as a church, was once more on

St Mary's Heritage Centre.

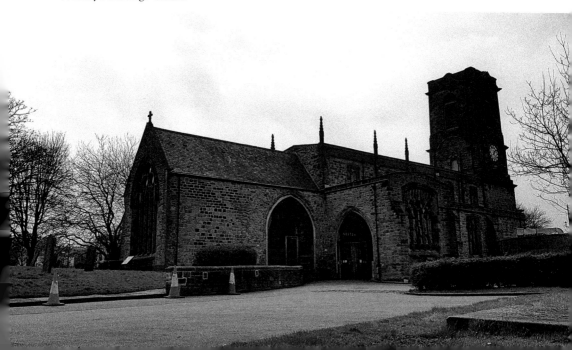

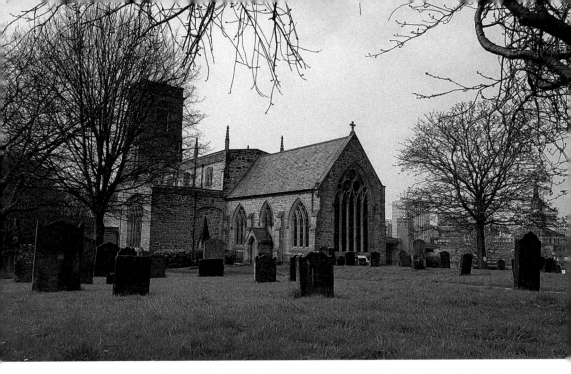

Above: The churchyard.

Below: St Mary's Heritage Centre. The Tyne Bridge can be seen in the background.

fire. This time fire consumed the building and it was largely destroyed. It was rebuilt to be used as an auction room, but in 1983 the building was once again damaged by fire.

Externally the church has changed little, but internally it has been completely transformed over the last decade. In a £1.2 million project funded by Gateshead Council, the European Regional Development Fund and the Heritage Lottery Fund, the interior of the Grade I-listed church was stripped out and reopened on 16 December 2008 as St Mary's Heritage Centre, a unique visitor attraction in a stunning location on the Gateshead Quay welcoming visitors to learning the history of Gateshead, incorporating libraries, arts and local heritage in one venue.

2. Holy Cross Church, Ryton

There has been a church in the village of Ryton since at least 1112. The current Holy Cross Church is the oldest building in the village, being built in around 1220. It was built in an 'Early English' style, on the 'bailey' of a motte-and-bailey castle which had been positioned here due to its excellent strategic position above the River Tyne.

In 1360 the upper tier of the tower was added along with the octagonal broach spire built of oak and covered in lead, which is visible for miles around as it stands 36 metres high. The beautiful stained-glass windows were added in around 1450. Another artefact of significance is a thirteenth-century marble effigy of a deacon holding a book.

In 1886 a major refurbishment took place, which also saw an extension added to the building. A large organ chamber to house a fine Lewis organ was added and two vestries.

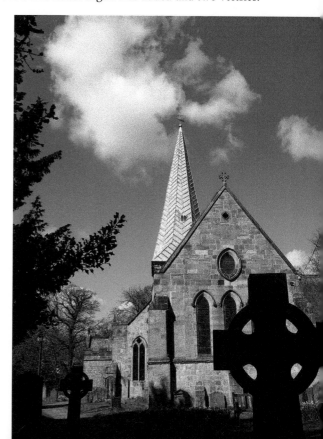

Holy Cross Church.

Above: The churchyard of Holy Cross Church.

Below: The octagonal spire can be seen for miles around.

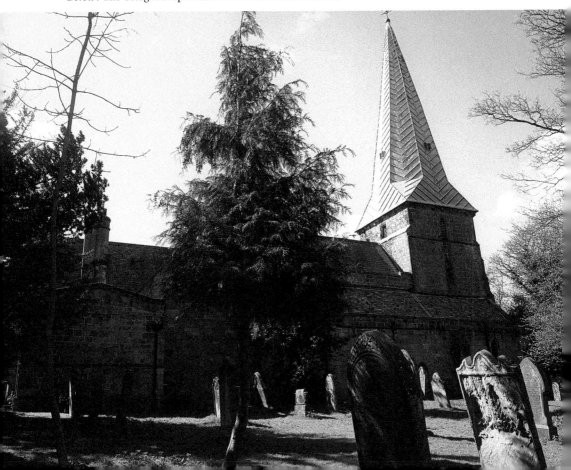

The stunning east window created by Charles Eamer Kempe was also added depicting the death, burial, resurrection and glorification of Christ.

To celebrate the coming of the millennium, a ring of eight bells in a cast-iron frame, which would be called the Millennium Ring, was designed and installed by Fred Pembleton of Chesterfield in Derbyshire. The existing derelict bell chamber already housed four bells, so these were carefully removed and taken to Taylors of Loughborough, the largest working bell foundry in the world, to be retuned to ring perfectly with the four newly cast bells. These were installed by 11 December 1999 and rang in the new millennium.

Today the Grade I-listed church has changed very little since the 1886 refurbishment and lamp posts, and some of the table tombs in the churchyard have been awarded Grade II-listed status.

3. St Edmund's Chapel

St Edmund's Chapel, situated on Gateshead High Street, was built in around 1247 on this site, which was known at the time as 'Gateshead Head'. It was opened as the Hospital of Saint Edmund, Bishop and Confessor 'for the spiritual refreshment of the soul'.

In 1594 John Ingram, a young Jesuit priest, was executed outside the building. He sacrificed his life for the Catholic faith during the religious persecution of the sixteenth

St Edmund's in 1950. (Photo courtesy of Gateshead Libraries)

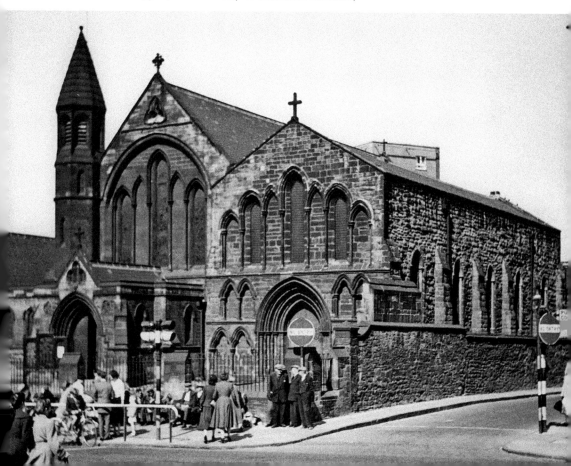

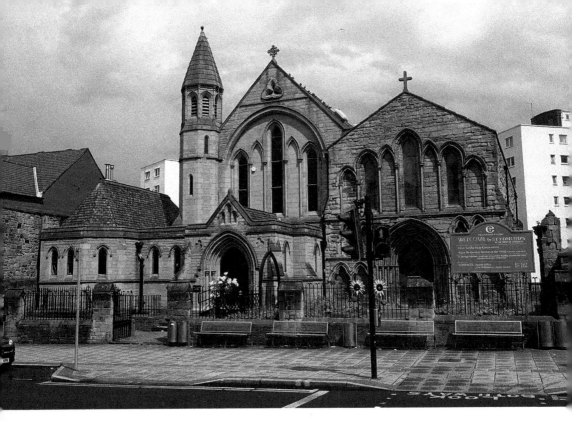

Above: St Edmund's in 2018.

Left: Stained-glass windows in the church are by the Atkinson brothers.

and seventeenth centuries, in which being as a Catholic priest was high treason punishable by hanging, drawing and quartering. He is one of twenty-six such priests executed during the period who were considered 'Martyrs of the North'. A stone cross was erected to commemorate the scene, as well as marking the head of the town of Gateshead.

The building fell into disrepair in the centuries following the Dissolution of the Monasteries. However, in 1837, the roofless building was restored with famed Newcastle architect John Dobson overseeing the work. There had since been another Saint Edmund's Chapel built on the old Durham Road elsewhere in Gateshead, so the building was reopened as Trinity Chapel.

In 1893, the building was extended and renamed once more as Holy Trinity Church. The building closed in 1969, and with the other St Edmund's long since demolished, it reopened in 1980 as St Edmund's Chapel, the parish church of Gateshead. The 1893 extension, to the left of the building, would become a community centre.

Since 2010 it has also been the venue for Sanctuary Artspace, a gallery installed along the north wall of the building with exhibitions held almost every week of the year.

4. Old Hollinside Manor

The ruined remains of Old Hollinside Manor lie a mile to the east of Gibside, on an isolated site overlooking the picturesque Derwent Valley.

The first recorded instance of the manor came in 1317 when Thomas de Hollinside granted his manor of Hollinside to William de Boyne (or Boineton) of Newcastle and his

Old Hollinside Manor.

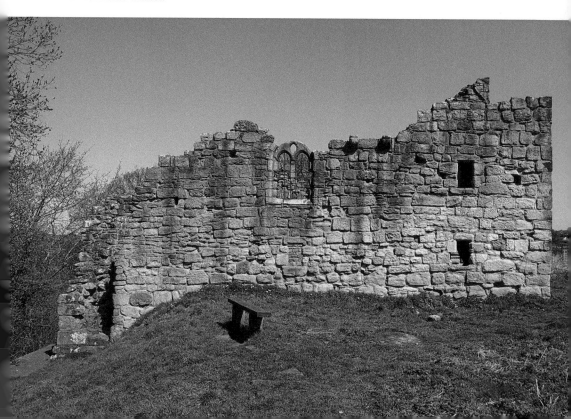

Above: West view of the ruined manor.

Left: Metal bars can be seen to reinforce the ruined building.

wife, Isolda. Historians are unsure of exactly when it was built, but it is likely that the sandstone structure was built as a fortified manor house in the thirteenth century with additional work being done during the fourteenth century. The manor was built with thick walls, leading to it being suggested that defence was important when this family home was constructed, such were the uncertainties of the times.

The manor changed hands many times in the years that followed, and by the fifteenth century it was owned by the Harding family. The Harding men were extremely tall. It is said that at least one topped 7 feet and Hollinside became known by the locals as the 'Giant's Castle', a nickname that is still used to this day.

The Hardings were associated with Hollinside for 200 years but they fell upon hard times during the seventeenth century and mortgaged their estate to the Bowes family. By 1732 it had passed into the hands of George Bowes by foreclosure and became part of the Gibside Estate.

The house became a tenanted farm but had become abandoned by the end of the nineteenth century. Decay set in, and its position has made it vulnerable to vandalism. It has been on English Heritage's At Risk Register since 2002.

In 2008 Stuart Norman, planning officer at Gateshead Council, said, 'There is some graffiti and stones have been dislodged. Youths have been climbing up the walls, dislodging the stones and then rolling them down the bank. They get enjoyment from dismantling it. There's a vaulted area to the remains which is an attraction to youths because it provides them with some shelter. It's become a den they congregate in and it's used for drinking and lighting fires. We get cans and bottles in there and the roof of the vaulted area is charred from the fires.'

An English Heritage grant enabled the council to begin a repair and consolidation scheme in the summer of 2008 on the Grade I-listed building. The Tyne and Wear Specialist Conservation Team say that it perhaps the best example of an unaltered medieval fortified manor in the county.

5. Gibside Hall

Gibside Hall was built within the country estate of Gibside between 1603 and 1620, on the site of a much older building. The hall was the vision of Sir William Blakiston with the estate having been in his family since 1540.

In 1713 the Gibside Estate changed hands, coming into the possession of the Bowes family with the marriage of Sir William's great-granddaughter and Sir William Bowes of Streatlam Castle.

1767 saw Sir William Bowes' granddaughter Mary marry John Lyon, 9th Earl of Strathmore and Kinghorne; however he was required to take the Bowes name as there was a clause in Mary's father's will. This was to continue the Bowes lineage without a male heir. The Bowes-Lyon family made a huge number of changes and improvements, including the landscaped gardens, Gibside chapel, and the avenue of over 200 oaks with the chapel at one end and the newly built Column of Liberty at the other. A banqueting hall was also built, to entertain guests.

By the end of the nineteenth-century Gibside Hall was no longer the permanent residence of the Bowes-Lyon family, and unmaintained the building began it's slow descent towards ruin.

Left: The Column of Liberty.

Below: Gibside Hall.

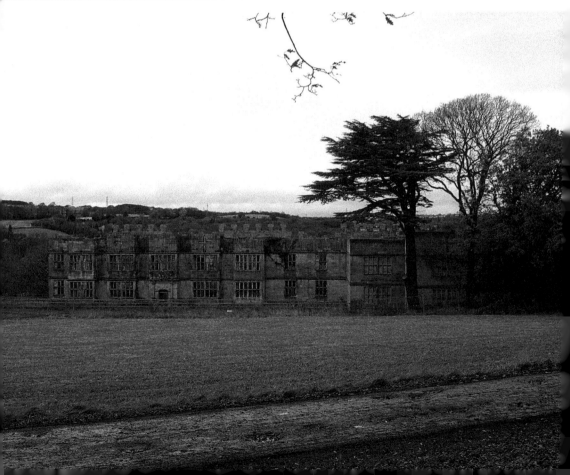

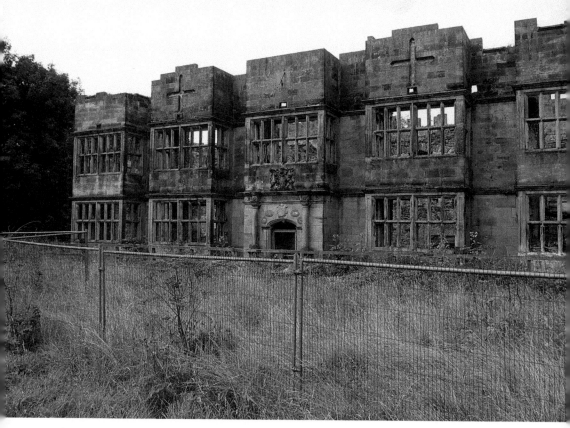

The hall is sadly fenced off as it's become too dangerous to go near.

In 1920 the family were forced to give up some of their magnificent residences and as a result anything of value was stripped from Gibside Hall and moved to Glamis Castle, in Angus, Scotland. In 1958 parts of Gibside Hall were demolished and the roof was removed, leaving the once great mansion open to the elements, accelerating the decay.

The rest of the estate was sold off in separate lots during the 1970s, including the Grade II-listed ruin of Gibside Hall, but the National Trust have since carefully reassembled Gibside and are restoring the estate to its former glory.

Sadly, it's too late to restore Gibside Hall, and today the hall has had to be fenced off as the building is unstable and could be dangerous. Work is underway to make the building safe so that visitors to Gibside may enter the hall once again.

6. Winlaton Forge

Ambrose Crowley III was born in 1658 in Stourbridge into a Quaker family in the business of ironmongery. By the age of fifteen he was apprenticed to Clement Plumpstead, a City of London ironmonger, where he excelled. In 1681 Crowley set up business for himself in London. However, by 1683 he had moved north and opened a factory making nails in Sunderland, having seen the potential offered by cheap and plentiful local resources and excellent yet inexpensive transport links out to sea from Tyneside and Wearside travelling down to London and back.

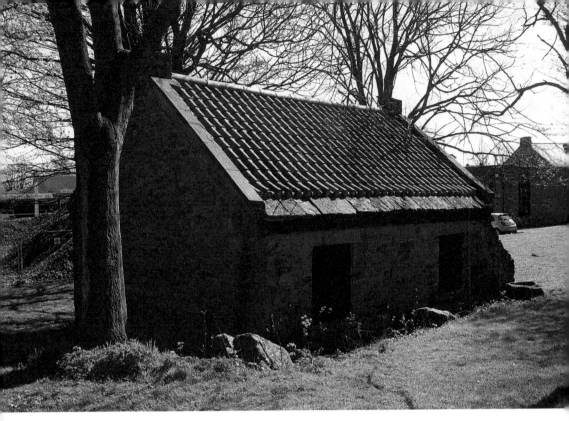

Above: Winlaton Forge.

Below: The entrance to the building that dates from the 1690s.

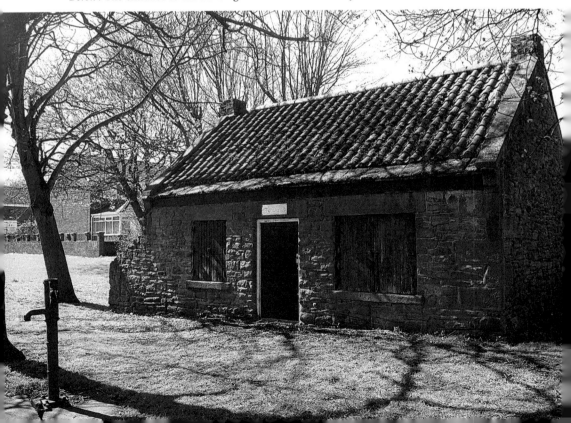

Evidence of a chimney can be seen in the brickwork.

In 1690 he relocated to Winlaton and it was here that he thrived. By 1697 he was advertising all manner of smith's ware for sale. The ironworks was expanded to Winlaton Mill, and in 1707 a rival business in Swalwell was bought out to accommodate the demand for Crowley's iron, mainly by naval contracts in which he had specialised. He had seen his combined ironworks become Europe's biggest industrial location, pioneering techniques and technologies that would be influential in the future of the metalworking industry.

His management methods were years ahead of their time, and the Crowley works were unique in having a written constitution to protect the rights of the workers. He also ensured his employees were part of an insurance scheme he established to pay for many social services for his workers, to which both employer and employees contributed. He contributed to local schooling and medical care. His ethos was work hard and you will be looked after, and it served him well.

Winlaton grew around the ironworks, beginning as just a few cottages; at its peak there were an estimated 1,500 men employed by Crowley's works, and the village became a small town of some importance.

The business made Crowley incredibly wealthy, and he was knighted in 1706 and became sheriff of London in 1707, before suddenly dying in 1713. His son John took over the business, and it was passed down through the family until his descendants sold the works in around 1845.

Now the Winlaton Forge is the sole surviving example of Winlaton's history of ironworks, a building dating back to around 1691 when Crowley first brought the industry here. It is now a Grade II-listed building.

7. Axwell Hall

In 1629 Mayor of Newcastle and merchant adventurer Sir James Clavering, 1st Baronet, purchased the Axwell Park estate, which included a manor house. His descendant, Sir Thomas Clavering, 7th Baronet, demolished the existing manor house in 1758 and had a substantial mansion built in its place to the Palladian designs of James Paine, one of England's most notable architects of the period. This mansion would be called Axwell Hall, and would be the seat of the family until the 10th and final Baronet, Sir Henry Augustus Clavering, passed away in 1893 with no heirs.

Axwell Hall's usage is unclear in the years between 1893 and 1922. It became an Industrial School in 1922, becoming an Approved School in 1933, an institution similar to a boarding school except that the young people who attend are made to go there by a court either because they've committed criminal offences or because they are beyond parental control. In 1933 there were around 150 'inmates', with these boys coming from Newcastle, Sunderland, Middlesbrough, Durham, Yorkshire and Northumberland.

The school was closed in 1981, and the hall and the majority of the 35-acre grounds of Axwell Park were sold.

Left empty and neglected, the Grade II-listed building, situated just east of Blaydon, began to deteriorate. This was until 2006 when property developers bought the hall and the estate to restore and convert the hall into luxury apartments.

The conversion of the hall is ongoing as of the spring of 2018; however the brand-new construction, named the Courtyard, stands next to the hall and is a luxurious, modern-style development offering five different types of houses for sale.

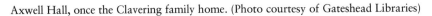

Axwell Hall, once the Clavering family home. (Photo courtesy of Gateshead Libraries)

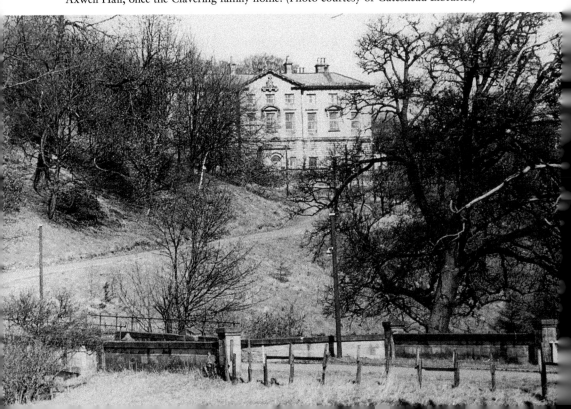

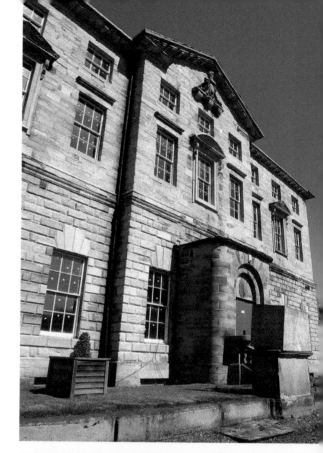

Right: Fenced off and empty in the year 2018.

Below: The newly opened 'Courtyard' homes.

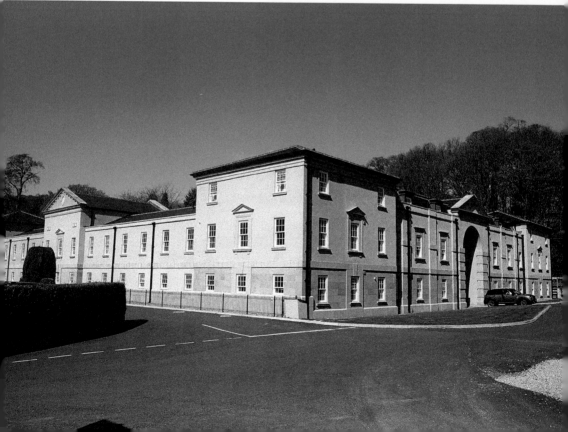

8. St Andrew's Church

St Andrew's Church is located in Lamesley, only a few hundred metres from the A1, in the base of the Team Valley.

The church once served the village that grew around it; however St Andrew's now stands alone with the exception of the Church Hall, formerly a school, to the north.

The church is a neat stone structure in the Early English style. The first church on this site dates back to 1286; however it was rebuilt in 1758 so extensively that nothing visible remains from the previous building, although church registers exist from as far back as 1603 and the church font is from 1664. Medieval grave covers can be found inside the church, and the family vault of the Ravensworths lies beneath the chancel.

In 1821 the church was extended, around the time the parsonage was built, with aisles and west tower. Further improvements were made in 1847 when £1,600 was spent rebuilding the chancel, and in 1884 £1,400 was spent on further restoration.

The west tower rises in three stages, and features a clock added in 1904 to commemorate the 3rd Earl Ravensworth who died in 1902. It was placed by his widow and a panel is inscribed 'To the glory of God and in memory of Athole 3rd Earl of Ravensworth, born 6th August 1833 died 7th February 1904.'

St Andrew's Church in 1914.
(Photo by E. Ruddock, courtesy of
Gateshead Libraries)

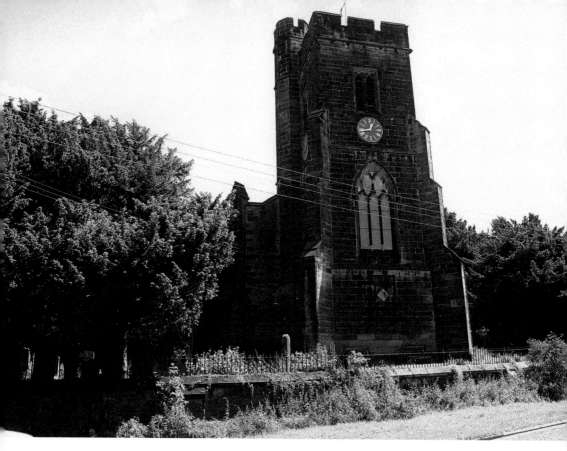

Above: St Andrew's Church in 2018.

Right: The clock commemorates the 3rd
Earl Ravensworth.

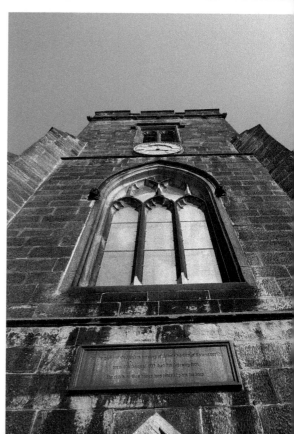

9. Gibside Chapel

The country estate of Gibside was acquired by the Blakiston family in 1540 by marriage. The year 1713 saw the Gibside Estate change hands, coming into the possession of the Bowes family, again due to marriage, with Sir William's great-granddaughter marrying Sir William Bowes of Streatlam Castle. 1767 saw Sir William Bowes' granddaughter, Mary, marry John Lyon, 9th Earl of Strathmore and Kinghorne; however he was required to take the Bowes name due to a clause in Mary's father's will. This was to continue the Bowes lineage without a male heir. The Bowes-Lyon family made a huge number of changes and improvements, one of which was the building of the stunning Gibside Chapel, which

Left: Gibside Chapel.

Below: The Grand Walk.

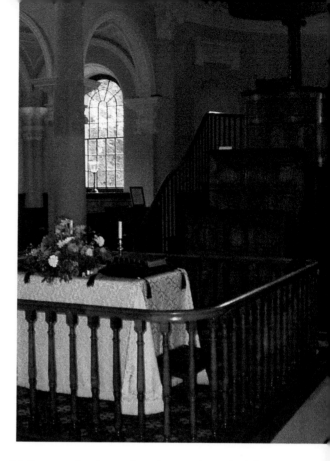

The interior of the chapel.

became the focal point of the wonderful Georgian landscaped gardens at the end of the half-mile-long, oak tree-lined Grand Walk.

It was designed by renowned Palladian architect James Paine, with the intention of it being the Bowes' family mausoleum. Work began on the chapel in 1760, which was built in a light-coloured sandstone sourced locally. However a few months later George Bowes, English Member of Parliament, coal proprietor, and head of the family, died, which led to a delay in the building of the chapel.

The exterior of the building was completed in 1769 by George's second wife, Mary, but the final touches to the interior weren't finished until the beginning of the nineteenth century.

When the building was opened for church services the congregation were traditionally seated according to their role and status on the estate. The family box was reserved for the Bowes-Lyons.

In 1965 the chapel was in the management of the National Trust, with the estate of Gibside having been neglected since the 1920s when the Bowes-Lyon family left and sold off some of the buildings to settle outstanding death duties. In the decades prior tenants had managed to secure the survival of Gibside Chapel by ensuring services continued.

Today, in the year 2018, the stunning Gibside Chapel is the jewel of the Gibside Estate, popular with the hundreds of the thousands of visitors who come here every year. It retains its original interior of cherry wood pews and rare three-tier mahogany pulpit. It also has a small collection of liturgical books, bound especially for the opening of the chapel in 1812.

A traditional Anglican service still takes place every Sunday led by the Revd Barry Abbott.

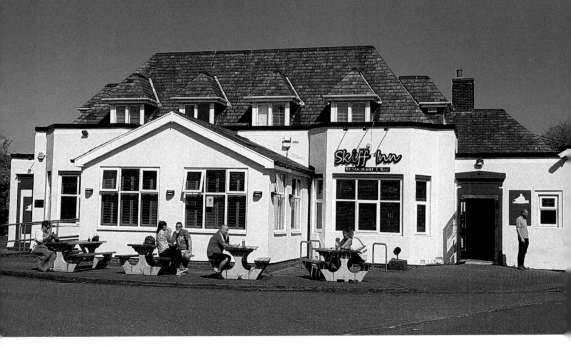

The Skiff Inn.

10. The Skiff Inn

Established in approximately 1800, the Skiff Inn is a pleasant public house, although it may appear, at first glance, historically insignificant. However the Skiff Inn was owned from 1836 by a north-east sporting superstar named Harry Clasper. Clasper was born in 1812 and was a professional rower and boatbuilder. He was a pioneering boatbuilder and developed a lot of innovations that are still used in boatbuilding today. Competitive rowing attracted crowds of over 100,000 on the River Tyne, and Clasper was their hero. He was very much the Alan Shearer of his day. He took the tenancy of the Skiff Inn, and in addition to being the pub landlord, the pub, being situated on the River Tyne, came with a boatyard, and he began to build boats here. He built two skiffs for himself – the *Hawk* in 1840 and the *Young Hawk* in 1841. With the latter he won the Durham Regatta Single Sculls race in 1842.

11. No. 19 West Street

The late nineteenth-century photograph opposite captures a large family home in Mirk Place, situated close to Gateshead's quayside. In this home celebrated engraver Thomas Bewick lived and died.

Thomas was born in 1753 in Mickey, a small hamlet near Prudhoe in Northumberland. He spent his entire working life in Newcastle upon Tyne as a general engraver on metal and copperplate, at the same time earning the reputation for being the father of modern wood engraving. Thomas never stopped working completely, although he semi-retired with his wife Isabella and their children to Gateshead, where they bought this house in 1812.

Despite being in the heart of the town, there were very few buildings around the Bewick family home, and he could see as far as the steeple at Holy Cross Church at Ryton 8 miles away.

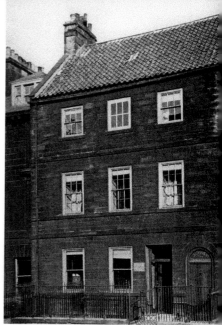

The new post office in 1905. (Photo courtesy of Gateshead Libraries)

No. 19 West Street in 2018.

Thomas died in the house on 8 November 1828, the same year that his wife, Isabella, also passed away. They were succeeded by their children, who continued to live in the Bewick family home. Jane Bewick, their eldest daughter, dedicated her life to the veneration of her father's memory, including the release of her father's memoirs in 1862, *A Memoir of Thomas Bewick*. Embellished by numerous wood engravings, designed and engraved by the author for a work on British fishes, and never before published, it is written by Thomas himself at the request of Jane in the final years of his life.

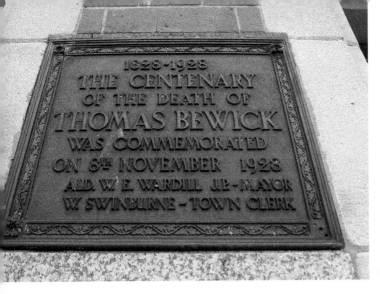

The plaque.

Jane passed away in 1881, and in the following year her younger sister, Isabella, anticipated a bequest that she'd agreed with Jane before her passing. They gave the British Museum a substantial collection of watercolours and woodcuts by their father, some of which had been exhibited in London in November and December 1880. Isabella passed away in 1883; both sisters died in the family home.

By 1897 the building had been demolished, as had all of Mirk Place, to make way for the current West Street. Upon the site of the Bewick home, No. 19 West Street was built as a post office.

The importance of Thomas Bewick's place in Gateshead's history has not been overlooked however, as the nearby Bewick Road was named for him, and today a plaque adorns the wall of the listed red-brick building that reads, 'Upon the site of this building stood the house wherein lived and died Thomas Bewick the wood engraver. Born 1753. Died 1828.'

The building is currently home to Workplace Gallery, a contemporary art gallery.

12. The Church of St Mary, Heworth

In the early nineteenth century the people of Heworth were served by a chapel that had been built in 1711 but which had become unsafe and was literally falling apart. This had started to drive the congregation away, so a decision was made to replace the chapel with a new church. On Wednesday 23 May 1821 the foundation stone of the Church of St Mary at Heworth was laid.

An architect had been appointed, but with little money to spend the vicar did most of the design himself. On 5 May 1822 the new church was used for the first time by the people of Heworth.

The building of the simple sandstone church cost £2,026 3s 4p. The church seated 1,400, but with the parishioners numbering in excess of this, the pews were numbered and were rented to the wealthier families.

On 6 August the new church was consecrated by the Bishop of Oxford; it was an important day for the village and crowds of people came. The church was full but there was no choir or organ to lead the singing, so a professional singer and a cellist were hired.

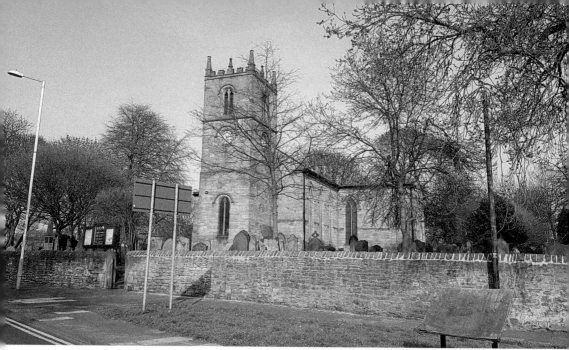

Above: St Mary's Church.

Right: The clock tower.

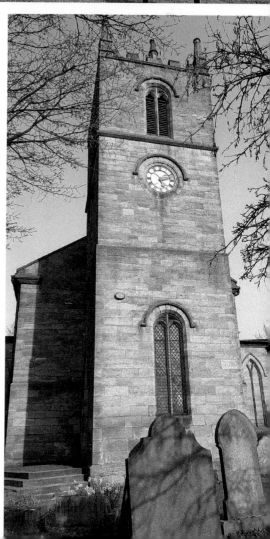

The Haddon tomb, one of the more elaborate graves in the churchyard.

By the time the church reached its centenary, a century of industrial pollution had coated the church's walls and turned them black.

The church has since survived many changes to the village of Heworth. By 1950 the village had begun to disappear, and when the Felling bypass was built it sliced not only through Heworth, but through the churchyard too.

The church was cleaned for its 150th birthday back in 1972, returning the exterior walls to their original colour.

The building of the Heworth Metro Station in 1975 saw the Church of St Mary on an island surrounded by traffic. In 1980 plans were drawn up to extend the Metro system to Washington, and this would see the Metro lines go through the site of the church. Fierce objection came from the parishioners, and these plans thankfully never came to pass.

13. St John's Church

In 1809 a decision was made that a church should be built upon Gateshead Fell. An acre of land was allocated for this new church and £1,000 was awarded by the Church Building Commission in the form of a grant.

Revd John Collinson, Rector of Gateshead, laid the foundation stone on 13 May 1824, and a few coins of that year were placed beneath. The building was completed the following year to the designs of architect John Ions and consecrated on 30 August. The total cost of the newly opened St John's Church was £2,742. The church's first Rector, Revd William Hawks, was inducted the following month.

At the turn of the century in the year 1900, the rector was Revd Johnathan Mitchell.

On 26 April 1950 the church was officially listed as a building of special architectural and historical interest and was awarded Grade II-listed status.

Internally the church has undergone major changes in recent years. Long-awaited building work commenced in 1998 to construct two meeting rooms, toilets and a kitchen. A Harrison & Harrison organ was salvaged from the disused St Aiden's Church in Consett. The church pews were removed and replaced with modern seating and the floors carpeted. This has

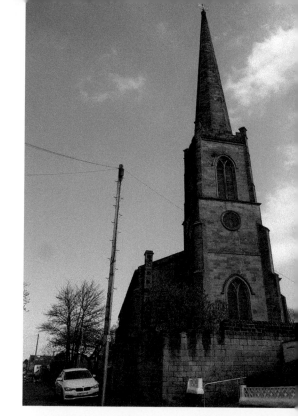

Right: The spire of St John's dominates the skyline for miles around.

Below: St John's Church.

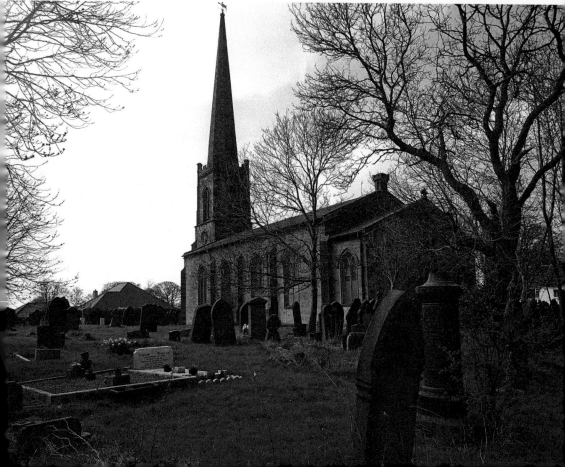

The churchyard.

brought St John's Church into the twenty-first century, and not only made it a more pleasant venue for church services delivered by the current rector, Revd Andrew West, but also allow for midweek activities, and the space has even been used for community purposes.

The church stands over 500 feet above sea level, and the spire is the highest point in all of Gateshead.

14. Gateshead Dispensary

Gateshead was hit by a cholera epidemic in December 1831. It was the first time cholera had landed on British shores and was due to a ship carrying sailors infected with the disease

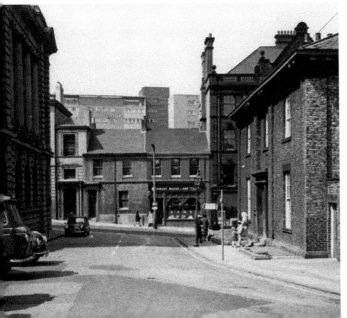

Nelson Street in the 1960s. The dispensary is on the right-hand side of the street. (Photo courtesy of Gateshead Libraries)

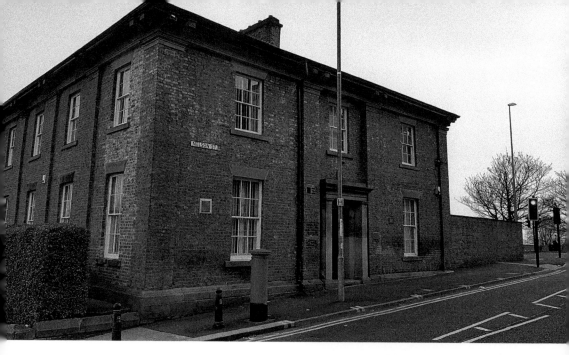

Above: The building that was once the Gateshead Dispensary.

Right: Plaques to the dispensary.

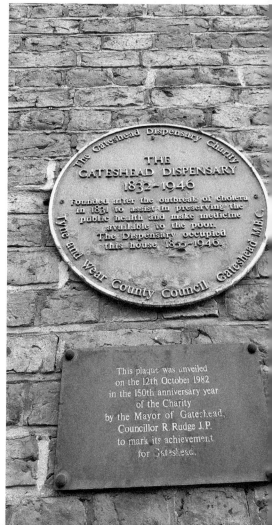

being allowed to dock in Sunderland in October of that year despite instructions from the government requesting that all ships coming from the Baltic states be quarantined. Doctors were only too aware of what cholera did to the body, but they didn't know how to stop the disease spreading, or how to treat the infected. Cholera took the lives of 234 Gateshead residents over a period of eleven months.

A dispensary to provide medical help to the poor was established at a public meeting in 1832 by residents including the merchant William Brockett who would go on to become Mayor of Gateshead, and Revd John Collinson. The first dispensary opened on 2 November 1832 on High Street. In 1855 a building on the corner of Nelson Street and West Street was bought to replace it. It functioned as Gateshead's dispensary until 1946.

In October 1982 a plaque was erected at the Grade II-listed building which was once the dispensary in recognition of the historical importance to Gateshead. It reads, 'The Gateshead Dispensary 1832–1946. Founded after the outbreak of cholera in 1831 to assist in preserving the public health ad make medicine available to the poor. The Dispensary occupied this house 1855-1946.'

The building that was once the dispensary has recently been completely refurbished and has become the headquarters for a national business travel company.

15. The High Level Bridge

Designed by Robert Stephenson and constructed between 1847 and 1849, the High Level Bridge is a road and railway bridge spanning the River Tyne. It was built for the York, Newcastle & Berwick Railway at a total cost of £491,153. It was the first major example of a wrought-iron bow-string girder bridge and provided a 'double deck' with railway traffic on a top level and road traffic below.

The High Level Bridge.

Above: The northbound entrance is now closed to traffic.

Right: Inside the High Level Bridge.

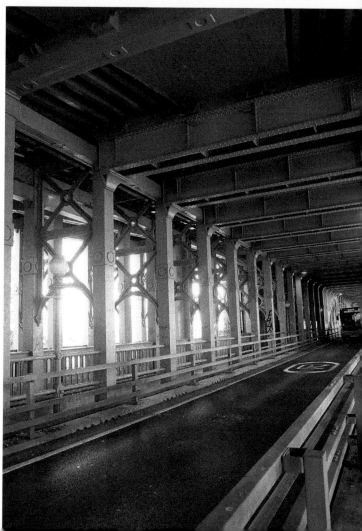

It was opened to rail traffic on 15 August 1849, with an official opening ceremony by Queen Victoria on 27 September. The lower level was opened on 4 February 1850.

When both Newcastle and Gateshead were devastated by the Great Fire of 1854, locals flocked to the new bridge, which commanded an unrivalled view as the flames consumed the towns below. It was written in *The Illustrated London News* that the High Level Bridge provided an excellent vantage point but 'began to vibrate like a piece of thin wire'.

Since construction of the King Edward VII Bridge, just to the west of the High Level Bridge, was completed in 1906 it took over as the train route along the Edinburgh–London East Coast Main Line, leaving the High Level Bridge to provide a route for local trains going to Sunderland, Middlesbrough and the Leamside Line.

In recent years the bridge has undergone extensive essential maintenance, which led to it being closed to road traffic in February 2005. Work included the need to replace timber supports and repair severe cracks found in some of the iron girders. Extra crash barriers were added to both sides of the roadway, which has left space for only one lane of traffic. Since the bridge reopened in June 2008 it carries only southbound road traffic, specifically only bus and taxis.

16. Lockhaugh Viaduct

Lockhaugh Viaduct, known locally as the 'Nine Arch Viaduct', was constructed in 1836. The single-track railway is built completely of sandstone. It stands 80 feet above a curve of the River Derwent, and is 500 feet long. It was built for the North East Railway, and

The Lockhaugh Viaduct carried the Derwent Valley Branch Railway until 1962. (Photo courtesy of Gateshead Libraries)

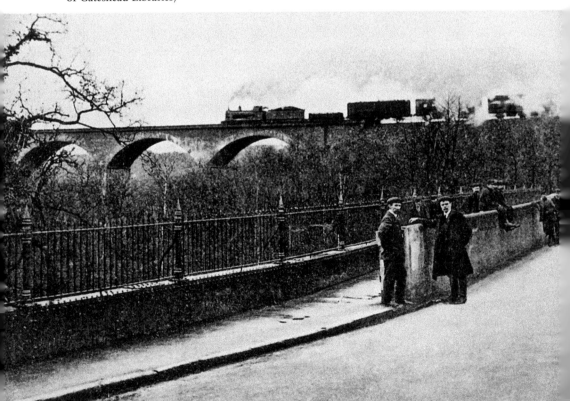

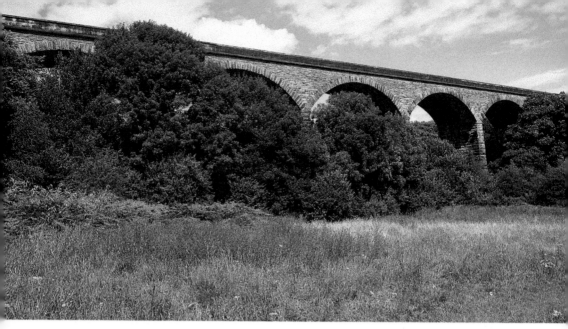

Lockhaugh Viaduct in 2018.

allowed the Derwent Valley Branch Railway to bypass Gibside Estate, because the Earl of Strathmore and Kinghorne would not allow the railway to pass through his estate.

In 1905 it was widened to incorporate a double track, which was completed in 1908. The Derwent Valley Railway closed in 1962 and the viaduct now forms part of the Derwent Walk, offering unrivalled views for miles around. To the south-west Gibside Estate is visible, and the most prominent feature is the stunning statue of *British Liberty* in the grounds, which cost around £2,000 when it was built between 1750 and 1759. The Roman Doric column stands 140 feet high and is topped with a 12-foot figure holding the staff of maintenance and cap of liberty.

The viaduct is a popular vantage point of 'twitchers' or birdwatchers to watch for the red kites which the Derwent Valley is famed for following their successful reintroduction into the area in 2004.

17. St Cuthbert's Church

The population of Bensham was steadily increasing during the 1830s and 1840s; however there was no church, meaning the people of Bensham had to go elsewhere for church services. However, in July 1846 the foundation stone of St Cuthbert's, in a prominent position on Bensham Bank, was laid. Its architect was celebrated Newcastle architect John Dobson. The final cost, all of which was raised through public subscription, totalled £2,000. It was opened for the people on Bensham in 1848.

It was built in a simple Romanesque style, with a high-pitched Welsh slate roof and a stone broach spire. It featured some fine stained-glass by Wailes and by Thompson.

The Grade II-listed building was in use until the late 1990s, but St Cuthbert's has faced an uncertain future ever since it closed its doors for the last time. Decay and vandalism set in, and things looked bleak until a plan in 2006 to save the church gave hope. The Society of St Pius X looked to take over the church, until they chose Christ Church in Gladstone Terrace instead.

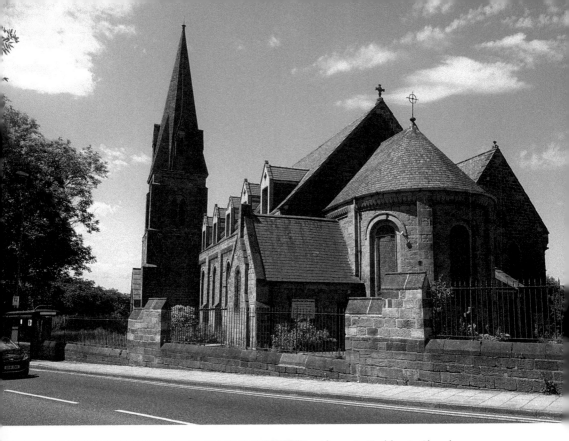

Above: St Cuthbert's Church.

Left: The glass in the windows has all been replaced in readiness for the top floor being leased as office space.

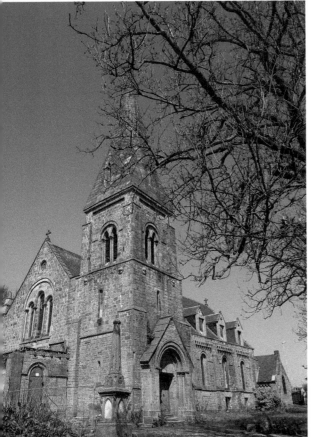

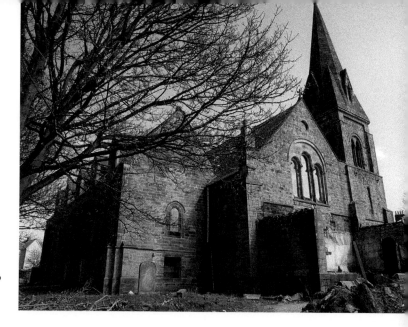

As can be seen here, there is a long way to go in the restoration of the church.

In 2007 the church was in such dire condition that it was sold for just £100 to the American-based religious organisation St Stephen The Great Charitable Trust. They planned to restore the church for their own use, which they estimated would take a year. However this never came to fruition and the church was left empty for a further decade, with plans for a stained-glass museum in 2013 raising hope but once again, not coming to pass.

The church has finally been saved, and as of March 2018 the converted roof space is available to rent as a unique office space.

18. Curleys Bar

Curleys on Gateshead's High Street began life at the Phoenix Inn. The earliest record of the building was in 1841 when the landlady was a sixty-year-old lady by the name of Jane Hindmarsh. The building was on the corner with Charles Street, one of the many streets of terraced housing leading off the High Street. However, Charles Street was demolished in the 1940s as part of the slum clearance programme, but the Phoenix Inn survived.

By 1873 it was in the ownership of a J. Lamb; however it would be the subsequent owner who would really become synonymous with the pub. His name was Will Cawley, but he was much better known as Will Curley.

Will Cawley was a boxer who fought American Patsy Haley in 1897 at Gateshead's Standard Theatre for the world 118 lb title when Will was aged just nineteen. He won that title fight comfortably and this would prove to be the first of many titles he would win during his career. He became known as Will Curley by accident. The boxing press misunderstood his Gateshead accent and began calling him Curley – and the name stuck.

By the time Will retired from boxing he was running the Phoenix Inn. He ran the pub, which had been nicknamed 'Curleys' by the locals, for over forty years until his death in 1937. Will's son Robert took over following his father's passing until 1964, when the bar was sold to Scottish and Newcastle Breweries.

In the 1970s the pub was still named the Phoenix but bore the name of its most famous landlord, Will Curley, above the door. In the years that followed it was officially renamed Curleys in the honour of the great man.

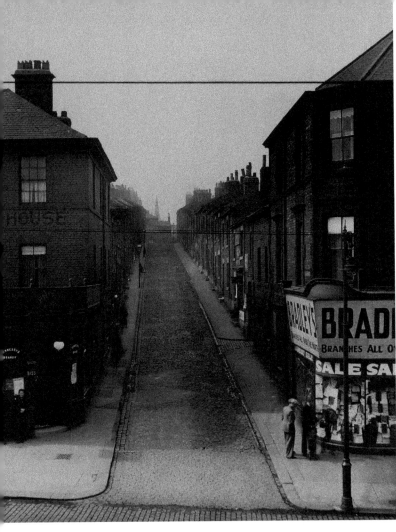

Left: The Phoenix
bar in 1940. (Photo
courtesy of Gateshead
Libraries)

Below: Curleys in
2018.

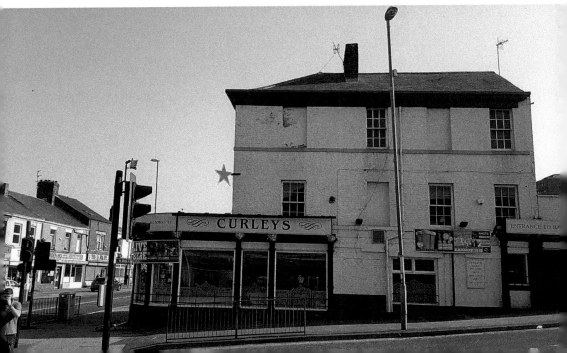

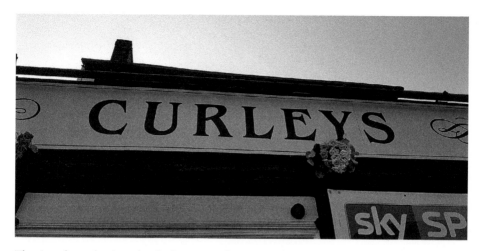

The sign above the door, for the bar's most famous landlord.

Today Curleys hasn't changed much; the main change is that the building next door has been demolished, leaving Curleys standing alone on the corner of the High Street.

19. St Joseph's Church

In the seventh century the Venerable Bede wrote of a monastery in 'Getehed' to serve the town's Catholics. After the Dissolution of the Monasteries in the sixteenth century, the estate came into the possession of the Riddell family.

Despite it being against the law, secret mass continued to be held until 1746 when the chapel, along with the mansion the Riddell family had built, was sacked and burned.

Gateshead didn't have a Catholic church for over 100 years, until in 1850 when plans were drawn up by the Bishop of Hexham and Newcastle, William Hogarth, to start a new parish to be named Our Lady and St Wilfrid's in Gateshead. He appointed Father Betham of St Andrew's Church in Newcastle to make the preparations.

St Joseph's Church in 1899. (Photo by E. Ruddock, courtesy of Gateshead Libraries)

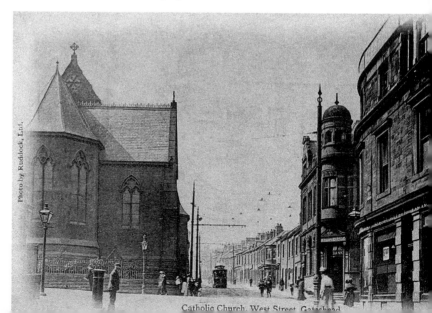

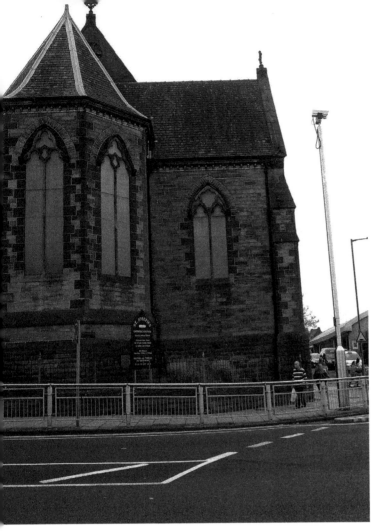

Left: The same view of the church as the 1899 photo, taken in 2018.

Below: St Joseph's Church.

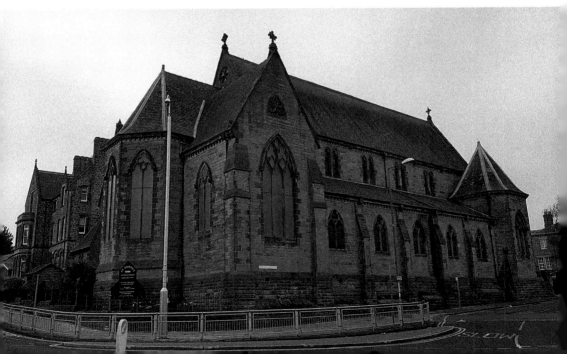

The foundation stone for the church was laid by Bishop Hogarth on 25 May 1858. St Joseph's Church was officially opened the following year on 5 July 1859. It cost £3,000, with the funding coming from public subscription, and was capable of seating 1,000. The decision to change the planned name for the church from the originally intended Lady and St Wilfrid's to St Joseph's came about during the church's construction due to a concern that it might be confused with the Cathedral Church of St Mary's across the river in Newcastle.

When St Joseph's opened it was the only Roman Catholic parish church in Gateshead and served 3,000. By 1959, when the church celebrated its centenary, the Catholics numbered around 20,000 and St Joseph's was one of seven Catholic churches in the town.

20. Saltwell Towers

Saltwell Towers, originally named Saltwell Park House, was built in 1862 in the centre of a 37-acre estate owned by William Wailes, who was a leading craftsman in the field of stained glass. It was designed to be an eclectic mix of Gothic and Elizabethan, with great asymmetrical towers dominating the exterior, with tall chimney stacks and a multitude of parapets built of dark brick, with patterns of yellow brickwork.

With Gateshead Council looking for a park for the people of Gateshead, William Wailes sold the estate and his family home of Saltwell Towers, with the agreement that Saltwell Towers be leased back to Wailes for the remainder of his life.

Wailes passed away in 1881, and in 1884 Saltwell Towers was bought by Joseph Shipley who lived there until his death in 1909. Shipley's enormous art collection and a generous donation left in his will would lead to the building of the Shipley Art Gallery on Prince Consort Road.

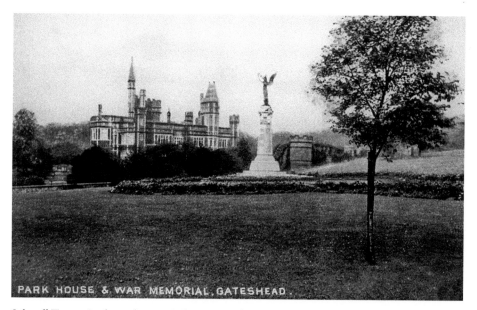

Saltwell Towers in the early twentieth century. The Boer War Memorial, erected in 1905, can be seen. (Photo courtesy of Gateshead Libraries)

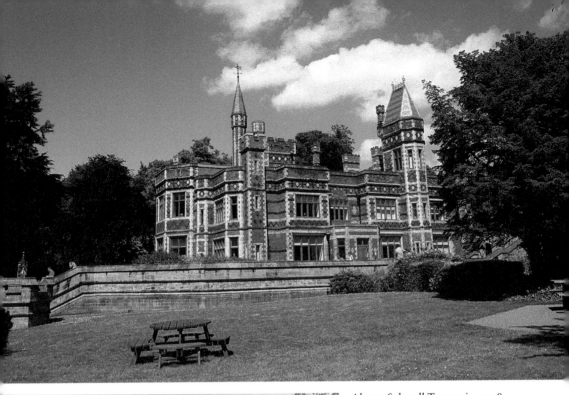

Above: Saltwell Towers in 2018.

Left: One of the great towers.

During the First World War the building was used as a hospital, and after the war ended in 1918 it was left empty. It remained empty for fifteen years, and then in 1933 it became an industrial museum from 1933. It remained in use as a museum for over three decades before it closed in 1968.

From 1968 Saltwell Towers, much like the park it stood in, fell into disrepair. Dry rot set in and the once great mansion of Saltwell Towers became a roofless, derelict shell, with only three external walls standing.

In 1999 a £9.6 million restoration project began, which would transform Saltwell Park and restore Saltwell Towers, the building at the very heart of the park for over 150 years.

On Wednesday 14 July 2004 Saltwell Towers was reopened, with William Wailes' great-great-grandson Peter Rankine Defty and his daughter in attendance as special guests at the official opening.

The mansion has been turned into the visitor centre for the park and includes a café, IT facilities and an exhibition on the fascinating history of the Saltwell Park and Towers.

In 2005 the Society of Chief Architects of Local Authorities (SCALA) awarded the restored Saltwell Towers its Civic Building of the Year award.

21. Birtley Co-operative Store

In 1861 the Birtley Co-operative Society was formed. The first co-operative societies appeared in the nineteenth century, spreading throughout Britain and France. As the 'Co-op' appeared in more and more towns and villages, it would be the most important store to the locals as those using the store would become members of the Co-operative Society and would be paid a dividend.

The Co-operative store in 1920. (Photo courtesy of Gateshead Libraries)

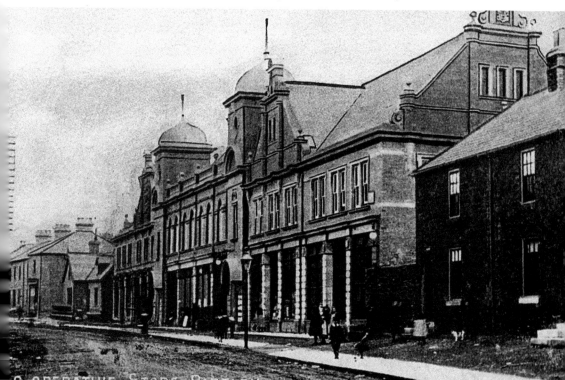

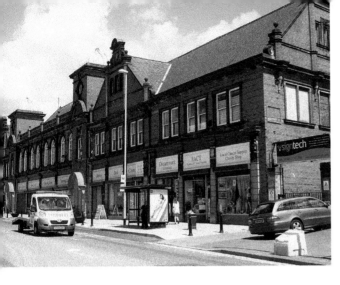

The former Co-op building in 2018.

The Birtley Co-operative Society's first premises was in Mount Pleasant, before moving to Durham Road, and then to a much larger location at Harras Bank. On Christmas Day 1900 disaster struck when fire broke out in the store, ravaging the building completely.

Rather than rebuild the Harras Bank store, the Co-op moved to a new permanent store on Durham Road.

Today the importance of the Co-operative Society has diminished as supermarket chains have extended and are the first port of call for most people when grocery shopping.

Birtley still has a Co-operative presence in the form of a popular Co-op food store, a travel agent, and a funeral parlour. Co-operative Food Supply Chain Logistics is a distribution business and the head office is in Birtley.

The former premises on Durham Road now house a number of smaller shops including a charity shop and a sandwich shop.

22. Whinney House

The land upon which Whinney House was built was bought in 1864 by John and Edward Joicey, two brothers who had made their wealth as coal owners. When Whinney House was built in 1867 it was the largest mansion in Low Fell, standing in vast grounds.

Later that year John handed over his share of Whinney House to Edward as a gift. Edward and his family were very happy living in Low Fell, and paid the £13,000 cost to build the new village church, St Helen's, which was built in 1876.

Edward passed away in 1879, and his widow, Eleanor, continued to life in Whinney House until her death in 1906.

The trustees of the estate let it out to a colliery owner from Morpeth, a Mr Fraser, who lived there until 1913 when it became a Catholic retreat designed to attract local workers to spend three days meditating and reflecting on matters of a spiritual nature.

In 1915 Whinney House became a temporary hospital, to tend to those injured in the First World War.

In 1921 it was used as a hospital to treat sufferers of tuberculosis, and then in more recent years as a centre for people with learning difficulties, and then a Jewish college.

In 2012 the Grade II-listed building was put up for sale with an asking price of £420,000. It was purchased by developers and converted into two- and three-bedroom luxury apartments.

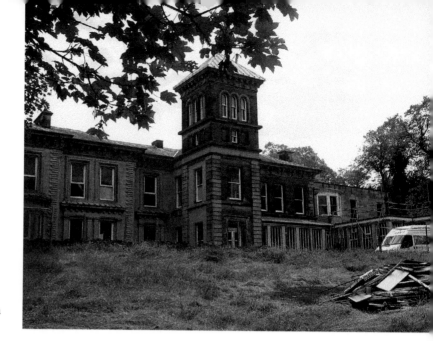

Whinney House being restored in 2014.

23. The Old Town Hall

The third building that had been designated Gateshead's town hall opened in February 1870. Mayor Robert Stirling Newall had laid the foundation stone on 11 June 1868, a ceremony which caused great excitement among the locals and saw thousands turn up for the event. The event, however, was a disaster as two special spectator platforms had been erected to accommodate the sizable crowd, but one of these platforms collapsed under the weight of 500 onlookers. Mr Barnett, a seventy-year-old from Windmill Hills, lost his life.

The building was considered cursed before it was even built by many superstitious Gateshead residents, and sadly they may have been right as more tragedy would befell the beautiful building in the years that followed. Death would strike the town hall again in 1935 when the Mayoress, Mrs Catherine White, suddenly collapsed and died on the steps of the town hall. In 1950 a lady lost her footing in a frenzied scramble for tickets to that year's World Cup.

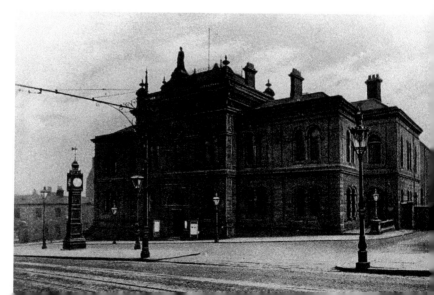

The Town Hall in 1904. (Photo courtesy of Gateshead Libraries)

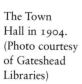

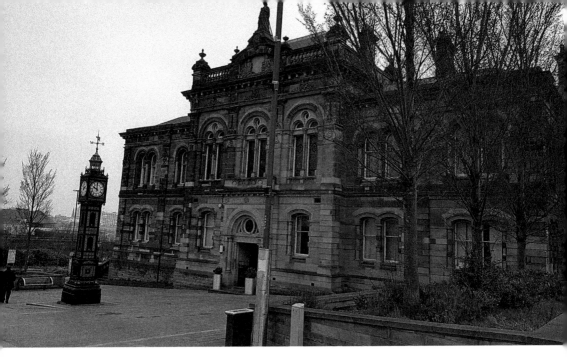

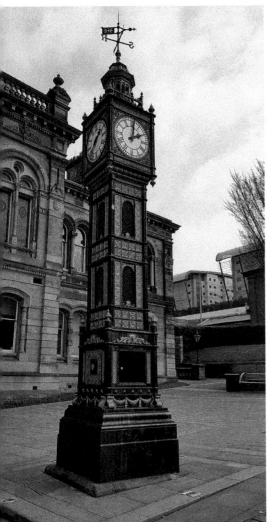

Above: The Old Town Hall in 2018.

Left: The ornamental clock presented to Gateshead in 1892 by mayor Walter de Lancey Willson.

The town hall remained the centre of the town's government for over 100 years until the current Civic Centre opened in 1987.

Unlike the town that it once served, Gateshead's Old Town Hall, as it has become known, has changed very little since it first opened for the people almost 150 years ago.

It had been used as office space for the council for decades until the interior and exterior were refurbished, and Sage Gateshead took over the management of the Grade II-listed building at the suggestion of Gateshead Council, and in January 2014 the Old Town Hall was opened as an intimate venue for performance and the arts, as well as being a stunning location in which to host conferences, events and weddings.

24. Scotswood Railway Bridge

The Scotswood Railway Bridge is a disused railway bridge crossing the River Tyne. It was part of the Newcastle and Carlisle Railway.

The first railway bridge across the river at this point was made of timber and was completed in 1839. Hot ash from a passing train in 1860 destroyed the bridge, so a replacement was built and opened the following year. A temporary single-track bridge was then built in 1865.

The amount of £20,000 was spent on a new improved bridge in 1871. It required strengthening in 1943. The bridge was no longer required by the railway by late 1982, as the trains on the N&CR were rerouted across the King Edward VII Bridge and through Dunston. Goods trains continued to use the line on the north side of the Tyne until 1990, taking coal to the Stella North Power Station and materials to the Ever Ready battery factory at Newburn.

Today the railway tracks have been removed and it is no longer possible to cross safely, although it's still used to carry water and gas lines over the river.

Disused Scotswood Railway Bridge.

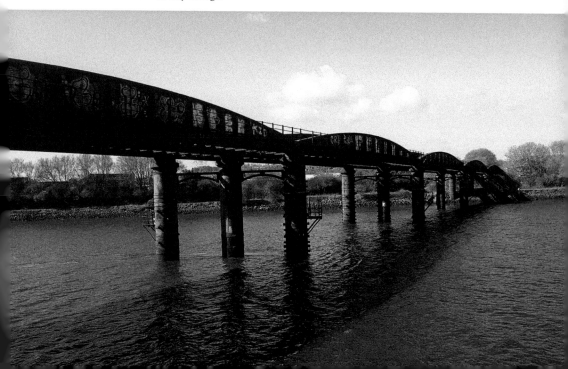

25. St Helen's Church

The foundation stone of St Helen's Church in Low Fell was laid on 29 October 1873, and the church was consecrated on 29 August 1876. It cost £13,000 to construct the church and this expense was met by coal mining magnate Edward Joicey, of the nearby Whinney House. The result was a beautiful Victorian stone church, built in the Early English style with an open timbered roof, cruciform in plan. The windows of the church are lancet-type and the stained-glass windows include the work of respected stained-glass makers Sir Edward Coley Burne-Jones, Charles Earner Kempe and George Joseph Baguley. The names of some of the makers of other stained-glass windows in the church are lost to time.

The church's organ is especially exquisite and cost £1,000 when the church was built. It was built by Father Henry Willis, notable organ builder. The organ required some restoration work and was rebuilt in 1949 by H. Vincent of Sunderland.

To encourage his colliery workers to attend Church, Edward Joicey built a bridge over Whinney Dene on his estate to make it easier for them to attend service.

The church could originally seat 500 but the number is now around 330 due to alternations and redesigns that have taken place since it first opened. It remains very much as it was built in 1876, and is still popular with the parishioners of Low Fell.

St Helen's is now a Grade II-listed building.

St Helen's Church.

Right: The spire can be seen for miles around.

Below: The churchyard.

26. Swing Bridge

The first bridge across the River Tyne was a wooden bridge built on stone piers, constructed by the Romans in around AD 120. This primitive bridge served the river for over 1,000 years, and in 1270 it was entirely rebuilt in stone. This new bridge lasted a further 500 years, but was swept away when the Tyne suffered extreme flooding in November 1771.

For a decade there was no bridge in place to cross the river, and then a replacement was built in 1781. However it was so close to the water that it caused problems transporting coal along the river and prevented larger vessels from moving upstream to Armstrong's factory at Elswick.

In 1864 the Armstrong factory, which had been manufacturing hydraulic equipment and cranes, began a potentially lucrative enterprise fitting lightweight guns of their own design to warships. William Armstrong realised the bridge was going to hinder this enterprise and offered to pay for a replacement bridge. A temporary bridge was constructed in 1866, and in 1868 the problematic bridge was demolished. Armstrong designed and paid for a revolutionary hydraulic swing bridge powered by steam pumps which would enable it to rotate through 360° to allow ships, no matter how big, to pass by without problem. This new bridge weighed over 1,200 tonnes. It was opened to road traffic on 15 June 1876 and for river traffic on 17 July 1876.

Armstrong's steam pumps were replaced by electric pumps in 1959. A few years later a solution was identified to a long-standing problem. Extremely warm weather caused the metal to expand and 'welded' it to its mountings, preventing the 'swing' action of the bridge. Up until this point the 'workaround' had been for the fire brigade to come out and douse the effected parts of the bridge with water. The solution came in the form of a light paint which reflected the heat.

The bridge still provides a vital road crossing and is permanently manned. The Swing Bridge often takes part in Heritage Open Days, offering a rare glimpse inside the bridge's control room.

The Swing Bridge.

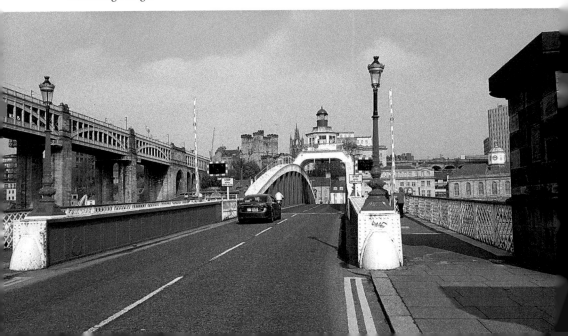

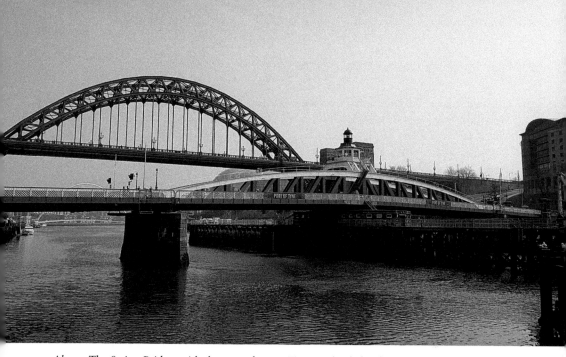

Above: The Swing Bridge, with the more famous Tyne Bridge behind.

Below: The Hilton Hotel can be seen overlooking the Tyne and the Swing Bridge.

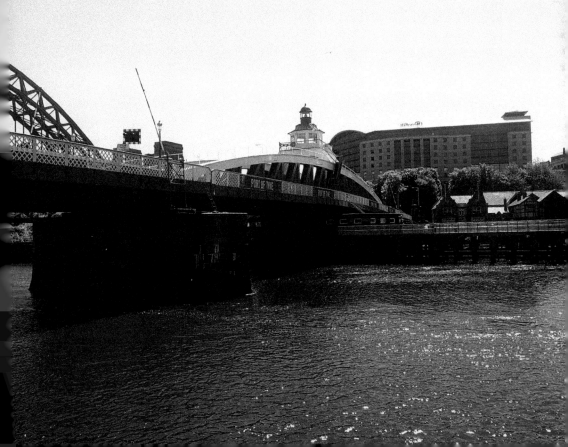

27. Durham Road Baptist Church

There have been Baptist churches in England since the early seventeenth century, and the first evidence of a Baptist presence on Tyneside is of a Baptist preacher in Newcastle in 1651.

On 12 September 1877 the foundation stone for Durham Road Baptist Church was laid. The present hall was the first part of the building to be constructed and the first services were held there on the first Sunday in December 1877. The church buildings were completed the following year and the opening service took place on Sunday 23 June 1878.

The Baptist church went on to become part of what was known as Amen Corner, or the Holy Corner, as it was the junction between Belle Vue Terrace, Durham Road, Gladstone Terrace and High West Street, and it was here that two other churches stood alongside the Baptist church – the Presbyterian church, and across the road the United Free Methodist church.

Of those three churches, only the Baptist church is still standing with most of the building that had surrounded it pulled down in the 1950s. In 2002 Durham Road Baptist Church celebrated its 125th anniversary.

Durham Road Baptist Church.

28. Co-operative Store, Jackson Street

The building on Jackson Street for the Co-operative Society was built in 1881. It was the first purpose-built premises that the Co-op in Gateshead owned, as for the twenty years prior they had rented property. The 'Co-op' would be seen as the most important store in the town or village to the locals, as those using the store would become members of the Co-operative Society and would be paid a dividend.

The Jackson street store was built in warm, local sandstone, with fine classical detailing and carving, including a large pediment supported on Corinthian columns with a crest at its centre. These period elements create an attractive frontage to the building, as well as offering a great deal of visual interest. Additional details include a plaque showing a beehive, which was the symbol of the Co-operative store. There is a coat of arms on the building with the sign of the goat. The goat has long been associated with the town of Gateshead – the town was known as Goats-head at one point in its history.

The Co-op served the town until 2007 when the building closed and was divided up into smaller retail spaces by London Reef Estates who purchased the grand old building.

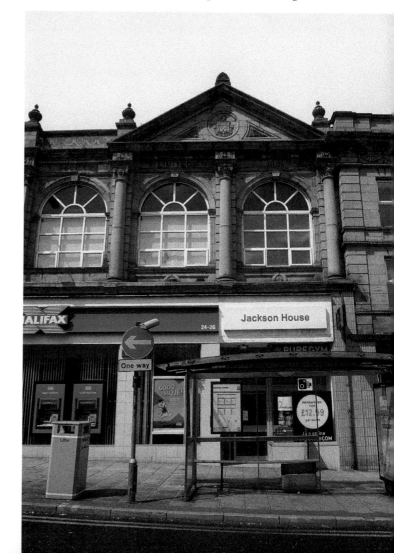

The Co-op building in Jackson Street.

The Gateshead coat of arms from 1881.

29. Wesley Memorial Chapel

The earliest Methodist church in Gateshead was originally built in Church Road in Low Fell in 1754, financed by William Bell, who owned a bakery on the same street with his wife, Jane. The Wesley Memorial Church on Durham Road, also in Low Fell, dates from 1882. It was originally a Wesleyan chapel and superseded the previous church.

The following year a church organ by Nicolson was installed in the chapel. Over the years the building has been expanded, especially in the early twentieth century when the Southern Memorial Hall was extended to be as large as the land available would allow.

Wesley Memorial Church in 2018.

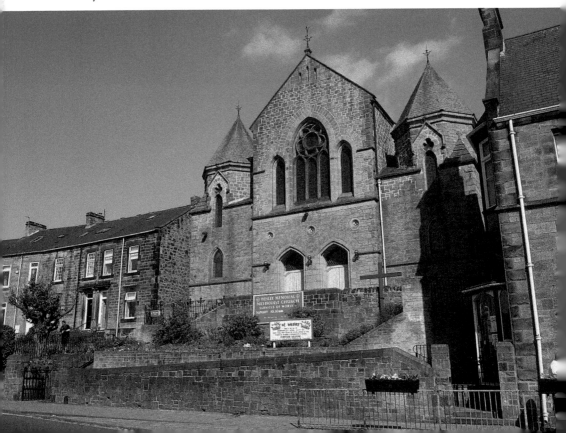

In 1997 a decision was made to give the church a major refurbishment. This was mostly completed by 2006, although there were plans to refurbish the church pews when funding allowed.

Today the beautiful Grade II-listed church continues to serve the local community, with Revd Huw John Sperring overseeing the church services.

30. Dunston Staiths

Dunston Staiths was constructed in 1893 at a cost of £210,000 by the North Eastern Railway to allow huge quantities of coal from collieries in Gateshead and County Durham to be loaded onto ships bound for London and abroad. At its peak in the 1930s, the staiths loaded more than four million tons of coal a year onto colliers (coal ships).

Dunston Staiths was closed in 1982 due to the demise of the coal industry, and was left abandoned, falling into disrepair as well as being vandalised and set on fire twice.

In 1990 some repair work was carried out so the staiths could be used for the National Garden Festival, taking a leading role as a key installation with performance space and an art gallery.

A serious fire in 2003 caused extensive damage, putting Dunston Staiths on Historic England's 'at risk' register.

Dunston Staiths, the largest timber structure in Europe.

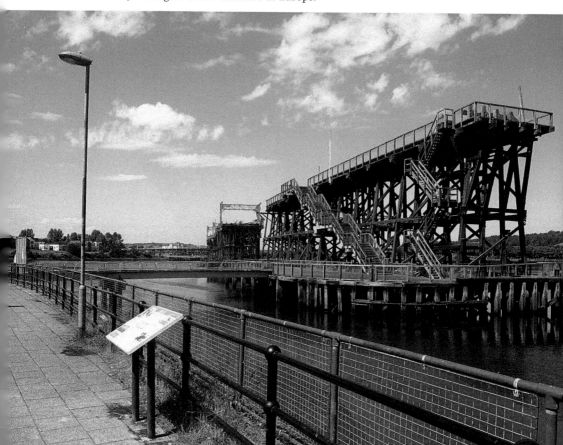

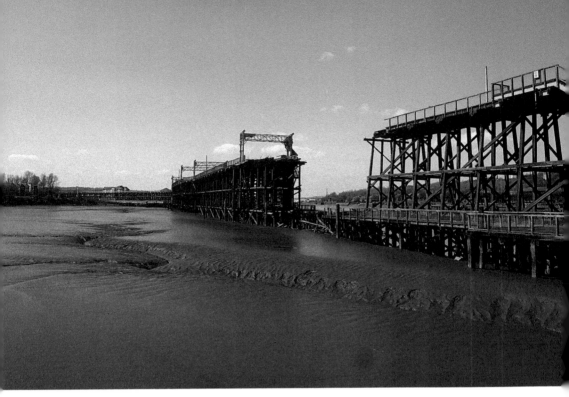

Above: There is still a large section of missing timber due to the extent of the fire damage.

Left: The west end is partially open.

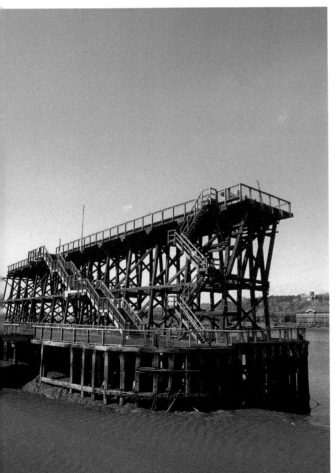

Today the 526-metre-long staiths is believed to be the largest timber structure in Europe and is a Grade II-listed monument. It is in the ownership of registered charity the Tyne and Wear Building Preservation Trust (TWBPT), supported by the volunteer group Staiths Friends, who are working together on an extensive restoration programme as well as looking to develop awareness and understanding of Dunston Staiths' significance, giving the staiths a long-term future through interpretation, events, activities and learning programmes.

The repair operation to the staiths cost £470,000, aided by a grant of £418,900 from the Heritage Lottery Fund and funds coming from English Heritage. The first phase of the restoration was completed in 2014–15, with forty of the ninety-eight timber frames being restored. This has enabled the partial reopening of the west end of Dunston Staiths, giving people the chance to walk along part of the staiths along the Tyne.

31. Scala and Metropole

The Metropole Theatre opened on 28 September 1896 to a production of William Barrett's play *The Sign of the Cross*. It was the largest theatre in all of Gateshead, seating 2,500 people, and it was also the most luxurious. It had a fine marble staircase with brass handrails and an elaborately decorated auditorium ceiling depicting angels arranging garlands. It was designed by the Newcastle architect William Hope, who designed a great many theatres around Britain in his time, and constructed for Weldon Watts by S. F. Davidson. It was situated on the corner of High Street and Jackson Street on the former site of a public house called the Masons' Arms. The plays were provided by touring companies and initially proved a huge hit; however by 1919 the touring production companies had declined in number and the building was converted to be used as a cinema, later renamed the Scala Cinema. The Scala was the first cinema in England to use rear projection, and a

The Metropole in 2018. The TSB stands on the site once occupied by the Scala.

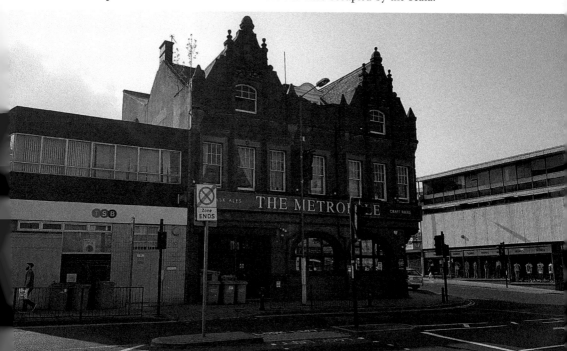

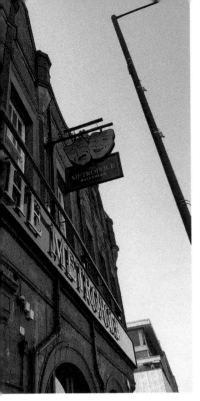

Left: A popular pub in the centre of Gateshead town centre.

Below: The wonderful nineteenth-century architecture stands out surrounded by modern buildings.

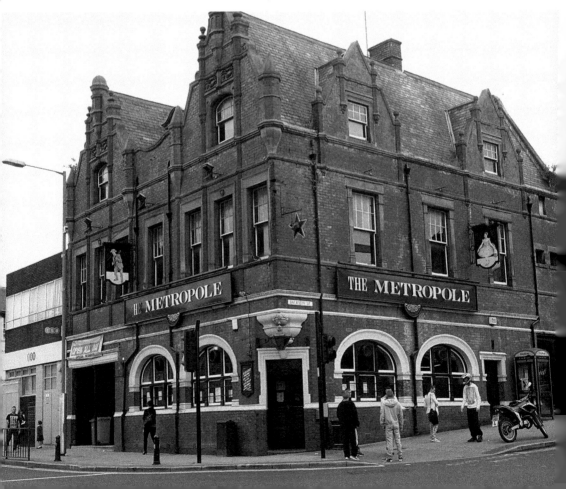

large orchestra would play the music to accompany the silent films until a cinema organ was fitted at the cost of £3,000.

The Scala Cinema closed in 1956, the year after the photograph shown (left) was taken, and in 1960 the cinema was demolished, although the Metropole Hotel which formed part of the building was spared.

Today the Metropole Hotel is now a public house called the Metropole and has changed little externally.

On the site of the once grand Metropole Theatre and the then Scala Cinema is a TSB bank, built in a style typical of the 1960s.

32. St Chad's Church

The Anglican church of St Chad in Bensham was designed by architect William Searle Hicks and was completed in 1903. However William had passed away in 1902, so never got to see his vision realised.

Emily Matilda Easton of Nest House in Felling met the costs for the building of the church. She had great wealth from her involvement in the booming coal industry; her brothers James and Thomas Easton owned many of the collieries across in the area.

The church was named for St Chad. In the seventh century Chad was a native of Northumberland. Along with his brother Cedd he was a pupil of St Aidan on the Holy Island of Lindisfarne, and would become abbot of several monasteries, Bishop of the

St Chad's.

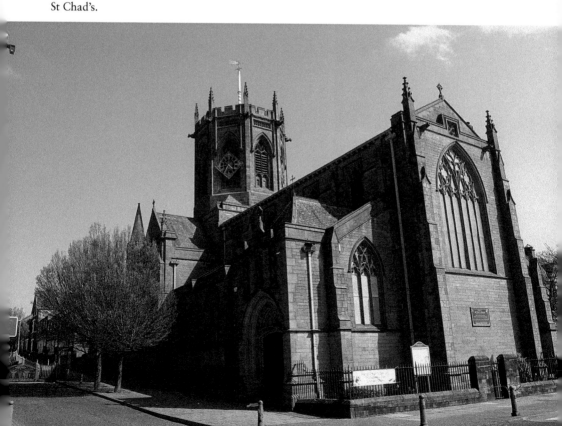

Left: The level of detail around this doorway is stunning.

Below: The unusual church spire.

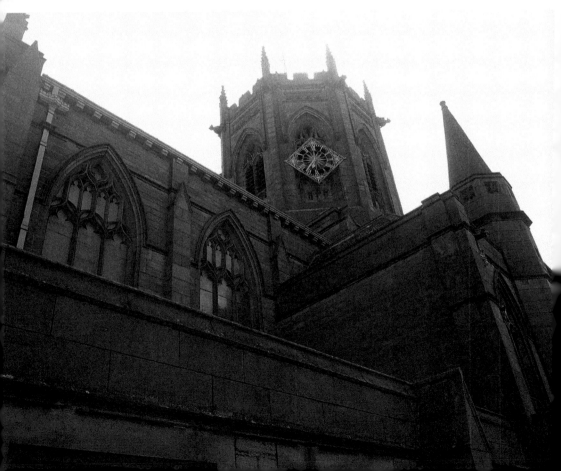

Northumbrians, and then Bishop of Mercia. He would later become a saint. He is credited with Cedd for bringing Christianity to the Kingdom of Mercia.

St Chad's Church was consecrated on 29 September 1903, and Miss Easton's nephew presented the petition on behalf of his elderly aunt. There were many notable members of the community in attendance including eighty members of the clergy, the Mayor of Gateshead, and the bishops of Durham and Newcastle.

The church's pulpit has elaborate carvings of famous sermons from the Bible, and a statue of the church's patron saint, St Chad. The lectern is a pelican, which may seem unusual in a church; however it's an ancient Christian symbol of sacrifice and Durham Cathedral has a similar lectern.

The east and west windows are by the Percy Bacon Brothers, and the west window is in memory of the architect William Searle Hicks. The north window was added around 1915 by stained-glass artist Leonard Walker as a memorial to Emily Easton and the Embleton family. A portrait of Emily Easton also hangs in the church. It is reputed to be the only example of Walker's stained glass in the north of England and contains scenes of the Ascension in the Arts and Crafts style.

33. The Harry Clasper

The Harry Clasper, now a JD Wetherspoons pub, started life as council offices for the district of Whickham. The attractive building was constructed in 1904 by the Carr-Ellison family, who then leased the building to the former Whickham Urban District Council. When Gateshead Council was created in 1974, the Whickham Urban District Council was dissolved, and the new council took over the lease of the property on Front Street.

The building was converted for the purpose of a public house, along with the demolition of outbuildings. The creation of an extension by JD Wetherspoons was met by furious objections from the locals. A spokesperson for the Whickham people said at the time, 'The extension should be avoided at all costs. It will completely change the character of one of the oldest parts of Whickham.' Despite these objections, the redevelopment of the old building went ahead and it opened in June 2014 as the Harry Clasper, named for a Victorian sporting superstar who was born in Dunston and is buried beneath a grand monument in the nearby St Mary's churchyard.

Henry 'Harry' Clasper was born in Dunston on 5 July 1812 and would become an internationally recognised sporting superstar, one of the most famous – if not *the* most famous – sportsman in Great Britain at the time. Clasper was one of a family of fifteen who was born into a humble life. At the age of fifteen, he began to work at Jarrow Pit, but soon decided that mining wasn't for him. He became ship's carpenter's apprentice in Brown's Boatyard before moving to the nearby Garesfield Coke Company as a coke burner and wherryman, then on to Hawks, Crawshay and Sons Ironworks.

Clasper, having gained invaluable experience in boatbuilding from his former employers, formed a racing crew with his brother William, John Thompson, and Robert Dinning, and another brother, Robert, as cox in a boat named the *Swalwell*.

At the time rowers were the first modern sporting superstars. The riverside was crowded with up to 100,000 people as entry for the races cost nothing.

Clasper took over the tenancy of the Skiff Inn on the Gateshead side of the Tyne, and in addition to being the landlord, he built himself boats on the same site. His designs and

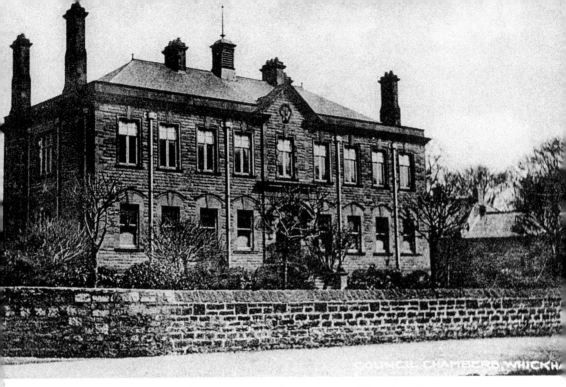

Above: The former council offices in 1920. (Photo courtesy of Gateshead Libraries)

Below: The Harry Clasper JD Wetherspoon pub in 2018.

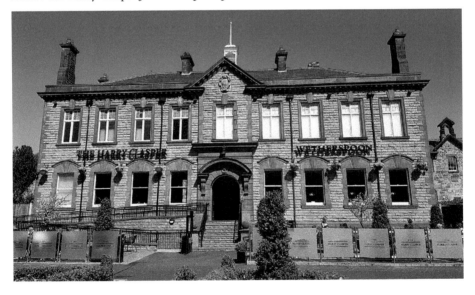

innovations helped him hugely with his success on the water, and many of his revolutionary designs are still used this very day.

Clasper would go on to dominate the racing scene with his 'Derwenthaugh crew'. They were awarded the title of 'four-oared world champions' and a whole host of other victories during a career that saw Clasper race over 130 times.

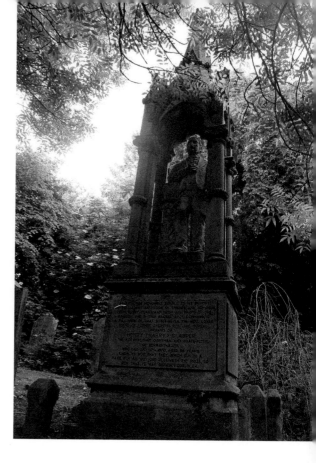

The Harry Clasper monument in the
nearby St Mary's Churchyard.

34. Imperia Cinema

The Imperia Theatre opened in November 1910 on Wellington Street in the centre of
Felling and had a seating capacity of 700. Proving even more popular than hoped, work
began in July 1915 to increase capacity and to add a cantilevered dress circle. This work
was completed the following year. In 1923 it was renamed the Imperia Cinema.

On 1 October 1929 the Imperia was devastated by fire. The building was too damaged
to be repaired and it was demolished.

In 1928, the year before the tragic fire, Joseph Smith had built the Palais de Dance
which stood in Victoria Square on the site of the former Paragon Theatre, which had been
demolished back in 1905.

With a gap in the market for a cinema, work began to convert the Palais de Dance for
this purpose, with the circle seating 210 and the ground floor seating a further 766.

On 25 August 1930 the New Imperia Cinema opened to the people of Felling, who
referred to it as the 'Pally'. The film showing on opening night was the new Janet Gaynor
and Charles Farrell musical *Sunny Side Up*.

In March 1932 a lounge opened in the cinema. The locals loved as it meant they could
come and dance. The Imperia was a popular place to go, but in February 1962 it closed
with the final showing being Irwin Allen's *Voyage to the Bottom of the Sea* starring Walter
Pidgeon and Joan Fontaine.

It became a bingo club in the 1970s, and in 1986 the New Imperia Cinema was granted
Grade II-listed status by English Heritage.

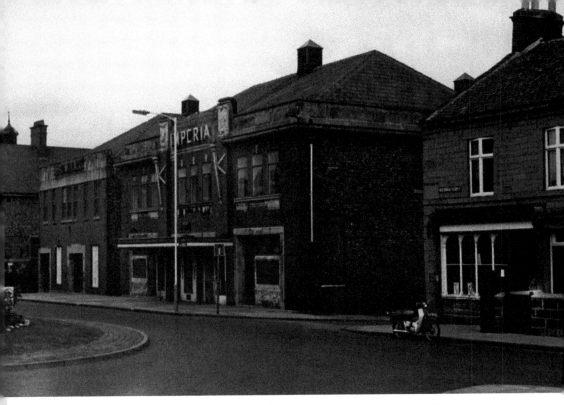

Above: The Imperia in 1977. (Photo by F. Manders, courtesy of Gateshead Libraries)

Below: The Imperia building in 2014, open as a bingo club but with no signage.

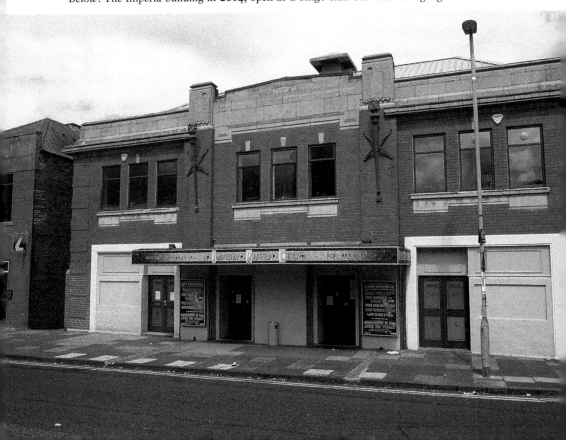

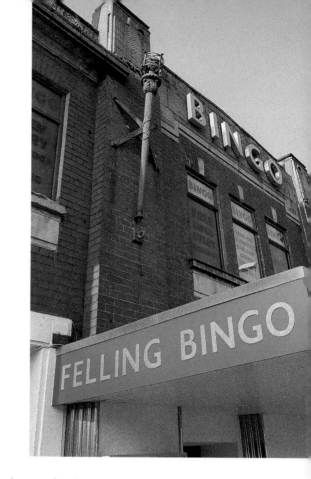

In 2018 the building is adorned with bingo signage.

In 2013, with the building having stood empty for three years, a £200,000 project was undertaken as part of a multimillion redevelopment by the Felling Syndicate, restoring and refurbishing the building to its former glory, to be reopened as a bingo club, Imperia Bingo Club, for the community of Felling to enjoy once again. At the opening general manager Martin Lagar said, 'It's a great opportunity for a lovely building. The building is full of history and character and it's great to open the building again. Over the years, the hall has played a huge part in the local community, and we wanted to bring something back to bring the community together again. It's not just bingo, it will be very much part of the community.'

35. River Police Station

After Gateshead acquired a town council in 1835, John Usher was appointed as Gateshead's first ever police constable on 20 January 1836, and the following week he was promoted to superintendent. By the end of April six constables were employed to work alongside Usher. In these early days the job mainly involved dealing with drunkenness and patrolling the old turnpike road. By the end of the decade Gateshead Police Force had two lock ups for prisoners, one of which was in the town hall and the other on the Gateshead site of the Tyne Bridge.

Encouraged by local shipowners, the Admiralty formed the River Tyne Police on 4 August 1845. The twenty-one men who made up this new patrol started policing the

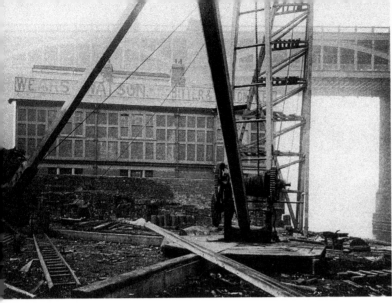

Construction of the River Police Station in 1910. (Photo courtesy of Gateshead Libraries)

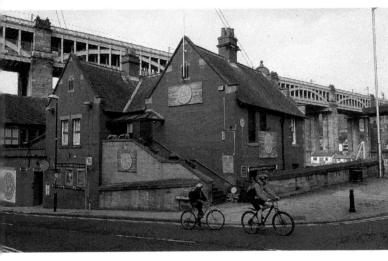

The River Beat restaurant now occupies the building.

river, armed with cutlasses, aboard one of six rowing boats available to them. They'd later get their own purpose-built River Police Station at the Gateshead side of the Swing Bridge. It was built by architects Fenwicke and Watson and was opened in 1910.

The station originally included cells used for holding illegal immigrants and other passengers not permitted found aboard ships entering the Tyne.

The River Police still patrol the River Tyne. They are still based at Pipewellgate, but they use fast boats and high-tech radios, a far cry from their predecessors of 1845. These policemen are responsible for patrolling the River Tyne and the coastal waters from Berwick-upon-Tweed to Ryhope.

In recent years over £50,000 has been spent transforming Pipewellgate House into River Beat, a relaxed restaurant offering tapas with an Asian twist. In the years leading up to this the building had been the police's administrative headquarters and home to the police diving team, before being home to a succession of restaurants. It is a Grade II-listed building.

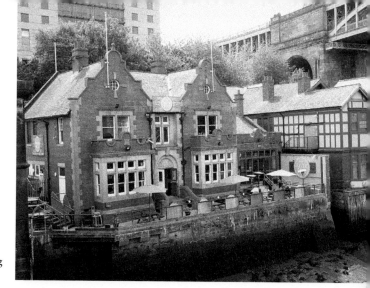

The former River Police Station viewed from the Swing Bridge.

36. Shipley Art Gallery

The Shipley Art Gallery opened to the public on 29 November 1917. This was only made possible due to a bequest from local wealthy solicitor and art collector Joseph Shipley, who had passed away in 1909. Shipley had lived a very private life and had amassed substantial wealth. He had lived at Saltwell Park House (now named Saltwell Towers) from 1884 until his death, and had amassed a collection of 2,500 paintings, a collection he is reported to have started when he bought his first painting at the age of just sixteen.

On his death Shipley donated a large amount of money to charity, and left all of his paintings to the City of Newcastle, along with £30,000 which was to be used to extend a gallery to house them. He specifically excluded the Laing Art Gallery from this as he considered it too small. After three years of debate and discussion Newcastle rejected this bequest, and the offer was passed on to, and accepted by, Gateshead Municipal Council.

Shipley Art Gallery.

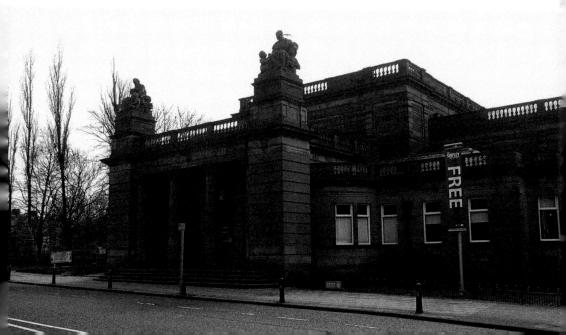

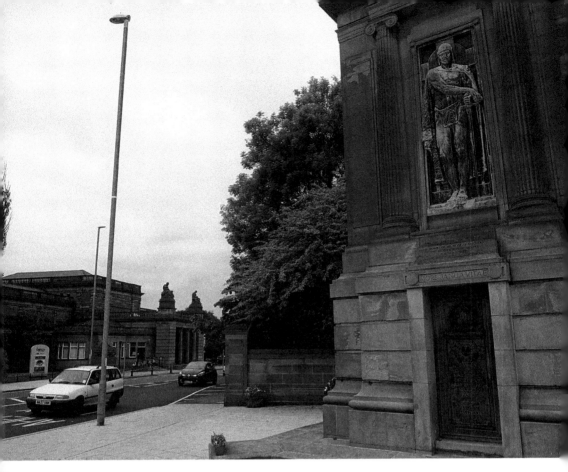

Above: Built in 1921, this monument is to those Gateshead men who lost their lives in the First World War.

Left: Joseph Shipley, on display in the gallery that bears his name.

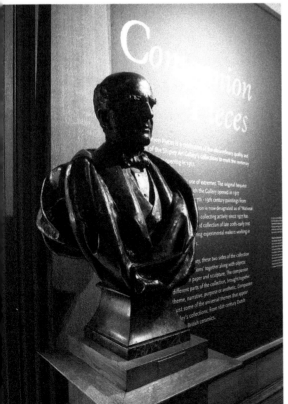

It was decided that it would be impossible to build a gallery that would be able to display the entirety of Shipley's collection, so the executors recommended 359 oil paintings and watercolours, and a further 145 were selected by the Gateshead's Committee. The remaining paintings were sold. The 504 selected paintings would make up the gallery's initial permanent collection and would be named the Shipley Bequest.

Work began on a new gallery at the south end of Prince Consort Road, designed by Arthur Stockwell of Newcastle. The building was built in a neoclassical style. The front was of stone with a Doric-columned portico roof. Two seated figures are surmounted atop these, one representing the arts and one representing science.

Today the gallery has changed little, although the collection within has continued to grow and now numbers over 10,000 items including the spectacular painting *The Blaydon Races* by William C. Irving. In 1977 Shipley began collecting contemporary art made in Britain. Over the last twenty-five years the venue has become established as a national centre for contemporary craft and has built up one of the best collections outside London, including ceramics, wood, metal, glass, textiles and furniture.

There are five gallery spaces showing a range of temporary exhibitions throughout the year. There are also regular events including artist and curator talks, family activities, concerts, and vintage and craft fairs. The Shipley Art Gallery is managed by Tyne & Wear Archives & Museums on behalf of Gateshead Council.

37. Gateshead Central Library

Gateshead's first library opened in January 1885 on Swinburn Street. It was built in a style described as 'Romanesque' with a carved head of Archimedes over the front porch. The opportunity to loan books proved incredibly popular with the people of the town, with 100,000 books being issued in the first year. The most popular books were a seven-volume

The Central library in 1933. (Photo courtesy of Gateshead Libraries)

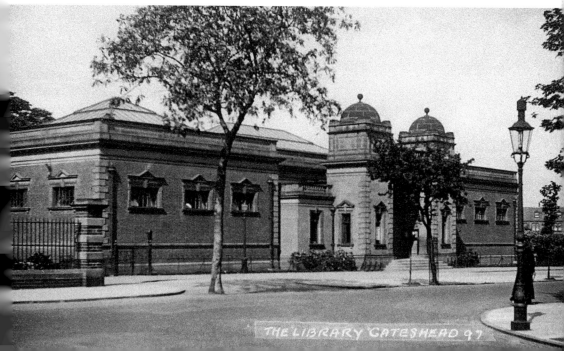

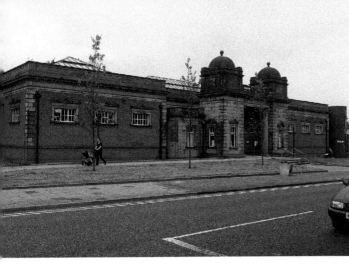

Left: The Central Library in 2018.

Below: This building was Gateshead's first library on Swinburne Street.

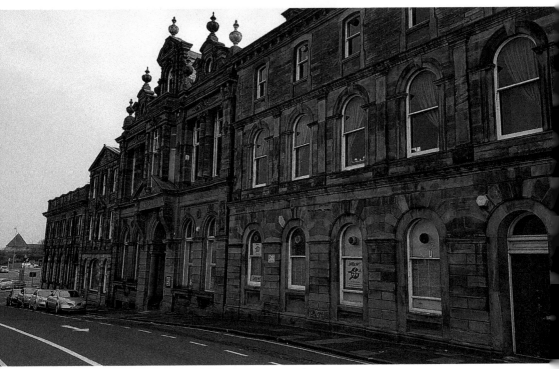

set of the history of the Crimea, a twelve-volume series of art at home, and a ten-volume set of Shakespeare. Demand for book loans increased year on year until the outbreak of the First World War when reading no longer seemed important in the face of conflict with the Germans.

At the end of the war books were more popular than before, and a larger library was required to serve the town. A site on Prince Consort Road was bought. Newcastle architect Arthur Stockwell, who had designed the nearby Shipley Art Gallery, was brought in to design the new library. The budget was reduced in 1925 due to money troubles and with Stockwell having passed away, the plans were revised by David Ditchburn.

The present library was opened on 6 April 1926. The original library was turned into a reading room for 'poor children'. The new library on Prince Consort Road led to the number of library members doubling and book loans increasing by over 33 per cent.

The building was extended in red brick in 1975–76 by borough architect Leslie Berry. The library is pictured here in the spring of 2018. It is now one of sixteen libraries to serve Gateshead but remains the main library for the borough. In 2010 the library underwent a £2.6 million transformation. With funding from the Big Lottery Fund and Gateshead Council this work created a new main entrance from the car park. This would also see the library offer a brand-new children's library, café, young people's space, gallery and a number of community rooms.

38. Tyne Bridge

The Tyne Bridge is arguably Newcastle/Gateshead's most iconic building. It is a through arch bridge spanning 531 feet over the River Tyne, linking Newcastle and Gateshead.

The suggestion that a bridge be built at this point of the Tyne was first raised in 1864, brought about because of the toll cost on the High Level Bridge. However it wasn't until 1924 that Newcastle and Gateshead authorities approved the construction of a Tyne Bridge. The estimated cost was £1 million including land acquisitions.

Work started in August 1925 with Middlesbrough bridge builders Dorman Long, who also worked on Sydney Harbour Bridge, acting as the building contractors. The work was very dangerous and one of the workers, Charles Tosh, lost his life during the construction.

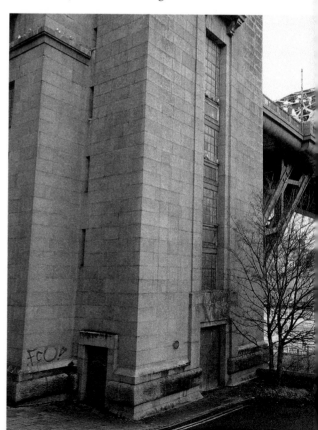

One of the enormous towers that support the Tyne Bridge.

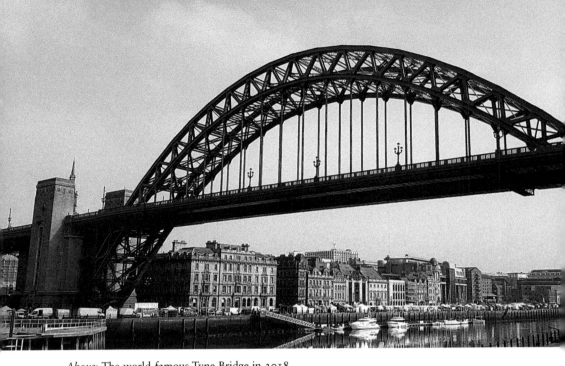

Above: The world-famous Tyne Bridge in 2018.

Below: In 2012 the Olympic rings were erected on the bridge for the London Olympics. This was illuminated each night.

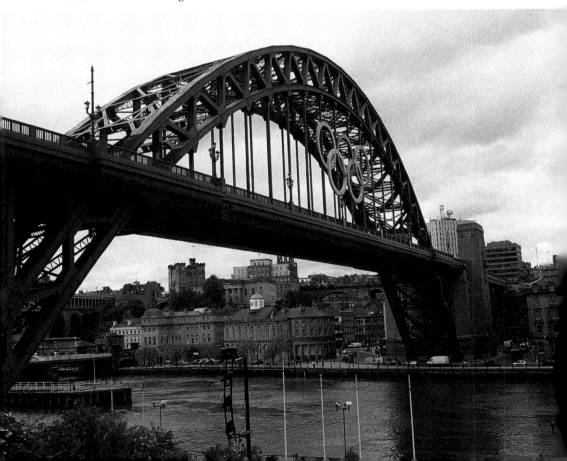

The bridge was completed on 25 February 1928 with a final cost of £1.2 million. It was opened on 10 October by King George V and Queen Mary, who were the first to use the roadway. The Tyne Bridge's great towers were designed by Newcastle architect Robert Burns Dick and were built of Cornish granite. They were designed as warehouses with five storeys. Lifts were built into one of the towers for passengers and goods to get up to the bridge level from the quayside. These are no longer in use.

On 10 October 1978, to celebrate the fiftieth anniversary of the bridge, 1,000 balloons were released into the sky above the Tyne Bridge. To mark the occasion the opening ceremony was re-created, with vintage vehicles and a procession of people in period dress.

The bridge is used by around 60,000 vehicles each day, and due to deterioration of the road surface major renovations were carried out in 1999. The following year the bridge was repainted in the same green colour that it had been when it was originally constructed.

The Tyne Bridge will forever be associated with the annual Great North Run, with over 50,000 runners crossing it at the start of the race as the Red Arrows fly overhead.

39. Dunston Hill Hospital

Dunston Hill Hospital was originally established as a War Pensioner Hospital in 1928, to replace a previous hospital at Castle Leazes over the river Tyne in Newcastle. It had previously been a large family home dating back to the early eighteenth century when it was built for John Carr of White House, who had bought the estate of Dunston Hill in 1704.

The hospital treated a lot of injuries that were acquired during the Second World War. The Ministry of Pensions controlled the hospital until 1953, at which point control was passed to the Ministry of Health. On 1 April 1956 it became part of the National Health Service and was administered by the Gateshead and District Hospital Management Committee.

For over fifty years the hospital provided mental health services and palliative care; however this came to an end in June 2012 when, with much of the hospital equipment coming to the end of its functioning life, a decision was made to close the hospital and move the patients resident there to new facilities at the Queen Elizabeth Hospital. This has left the future of Dunston Hill Hospital uncertain, and six years on the building remains unused.

Dunston Hill Hospital in 1910. (Photo courtesy of Gateshead Libraries)

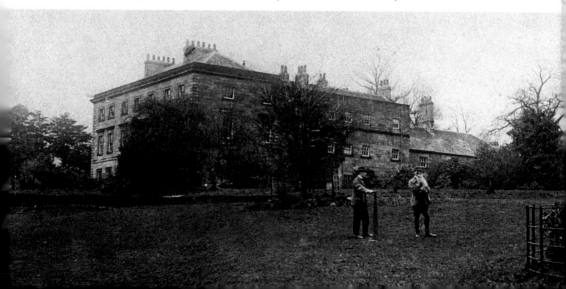

Dunston Hill Hospital in 2018, still empty and unused six years after helping its last patient.

40. BALTIC Centre for Contemporary Art

In the late 1930s work began clearing land on the former site of the Gateshead Iron Works, famous for casting the 5,050 tonnes of iron used to construct the High Level Bridge. This land would become the site of the new Baltic Flour Mill, designed by Hull-based architects Gelder and Kitchen for Rank Hovis. The foundations were constructed towards the end of the 1930s, but the outbreak of the Second World War halted the project.

With the war finally over, work resumed on the mill in 1948, and it was finally completed in 1950. Despite being designed in the 1930s, it was equipped with the most modern machinery of the time and could despatch 240 tonnes of grain every hour.

At its peak around 300 people were in the employ of the Baltic Flour Mill, with a number of them moving to Gateshead from all over the country to work there. In 1957 an animal food mill extension was built, and the Baltic became a dual-purpose mill, producing animal feed as well as grain.

After a little over thirty years in operation the Baltic Flour Mill ceased production in 1981. After two decades of neglect and decay, the future of the unused building, sitting on prime land right on the bank on the River Tyne, looked bleak. However, in 2002 plans were drawn up to convert the building into an international centre for contemporary visual art. An architectural design competition was launched by Gateshead Council and the Royal Institute of British Architects, and in 1994 Dominic Williams of Ellis Williams Architects, London, was announced as the winner.

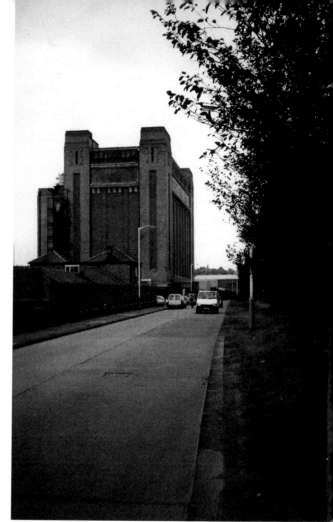

Right: The empty Baltic flour mill in 1991. (Photo courtesy of Gateshead Libraries)

Below: The building today is part of the transformed Gateshead Quays.

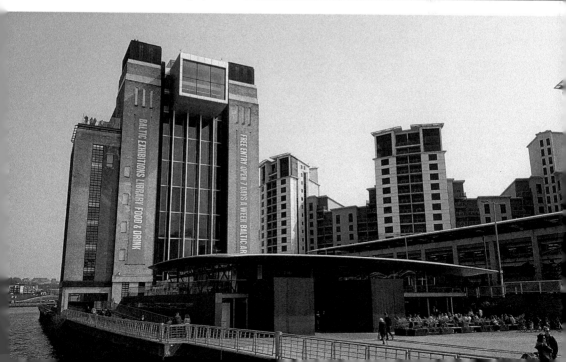

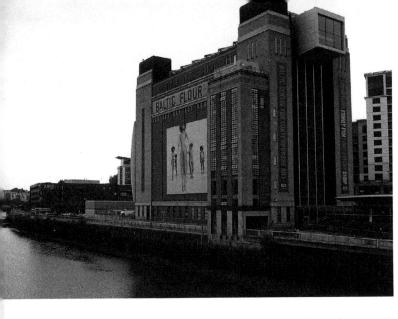

Millions of visitors
have enjoyed
the galleries and
exhibitions since the
building opened.

Work began on the project in 1998, costing £50 million, backed by £33.4 million from the Arts Council Lottery Fund. Only the south and north walls and the four brick corner towers of the original building remain. A completely new interior consisted of six main floors and three mezzanines offering 3,000 sqm of arts space, artists' studios, cinema/ lecture space, a shop, and a library and archive for the study of contemporary art. This is topped off by a glass rooftop restaurant offering stunning panoramic views of Gateshead, Newcastle and beyond.

The BALTIC Centre for Contemporary Art opened to the public at midnight on Saturday 13 July 2002, and the inaugural exhibition, B.OPEN, attracted over 35,000 visitors in the first week.

The BALTIC has proved a huge success with over five million visitors passing through its doors to date. Along with the Millennium Bridge and the Sage Gateshead, the BALTIC has helped to transform Gateshead Quayside.

41. The Little Theatre

The Little Theatre was the only theatre in Britain built during the Second World War. It was built on a derelict site that would have housed Nos 1 and 2 Saltwell View, purchased in 1939 thanks to the generosity of sisters Madeleine-Hope, Ruth, and Sylvia Dodds of Low Fell, renowned public figures in the early twentieth century – Madeleine-Hope was at Cambridge before women could be awarded degrees, and would also write a book, *The Pilgrimage of Grace*, which would be considered one of the most definitive books on church history; Ruth was a prominent Labour politician in Gateshead during the 1930s and would become a honorary freeman of Gateshead in 1965.

Building a theatre during hostilities led to a number of interruptions: at one point it was requisitioned as a barrage balloon station, and on another occasion a bomb fell on nearby Saltwell Park and it blew out the windows and doors of the theatre. With the theatre finally ready to put on shows for the people of Gateshead, the opening performance was of *A Midsummer Night's Dream* on 13 October 1943.

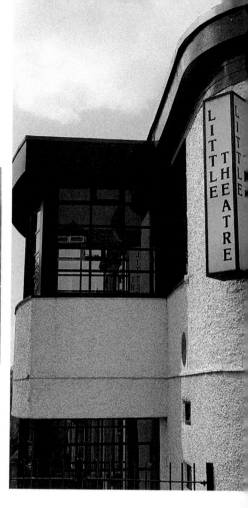

Above: As can be seen in this photo, the charming Little Theatre is surrounded by houses.

Right: The Little Theatre in 2018.

Below: The Little Theatre underwent a facelift in 2013.

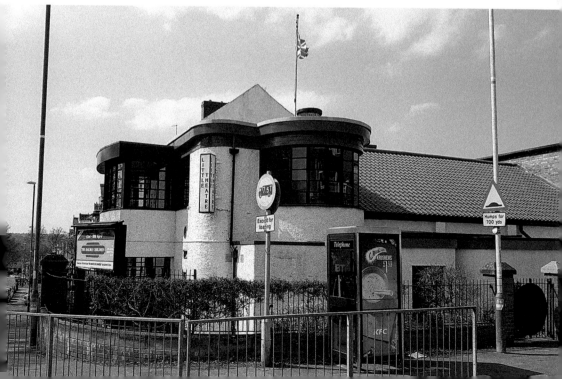

No. 3 Saltwell View came up for sale and was purchased and incorporated into the new building immediately. The Little Theatre and the Progressive Players, a repertory company formed in 1920, and who would perform most often at the Little Theatre once it opened, went from strength to strength. But during the 1960s and 1970s things looked bleak for the theatre, with the threat of demolition hanging over the building to make way for a new road. However thankfully, this never came to be. In 1989 No. 4 was purchased to ease overcrowding and allow further expansion. In recent years the building, which is now Gateshead's only theatre, had undergone a major facelift, which was completed by late 2013, in time for the building's seventieth birthday.

42. The Queen Elizabeth Hospital

The Queen Elizabeth Hospital, based in Sheriff Hill, started life as an infectious diseases isolation hospital in the late nineteeth century. Work began to extend the existing hospital in 1938; however construction was soon halted due to the outbreak of the Second World War. The hospital's maternity ward was in use from 1943, and the hospital was completed and used from 1945. It was officially opened three years later when the extensions to the hospital were officially opened by Queen Elizabeth, later known as the Queen Mother and for who the hospital is named, on 18 March 1948. The newly extended hospital contained 110 beds and thirty-four maternity beds. Queen Elizabeth met nurses, doctors and patients during the royal visit, as well as visiting the maternity unit.

Further improvements to the hospital were carried out in 1967, with the addition of an outpatients department (which is still in the same location today), A&E, a medical records department, and a new operating theatre. However, also in 1967 there were separate dining

The £32 million Queen Elizabeth Emergency Care Centre.

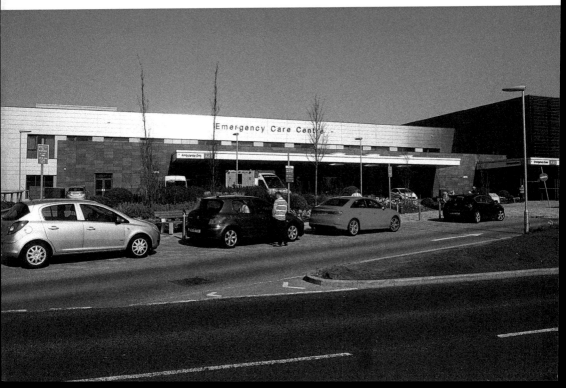

Right: The outpatients department.

Below: The Queen Elizabeth Hospital has undergone huge investment in recent years and is now an enormous hospital site.

rooms for nurses and consultants, who weren't allowed to mix during their lunch breaks. This shows how much times and attitudes have changed in the decades since.

In the year 2018 the Queen Elizabeth celebrates seventy years since the extended hospital was opened. It is now one of the north east's leading healthcare centres. A brand-new £12 million pathology centre of excellence was opened in 2014, and a £32 million emergency care centre was opened in February 2015. The hospital also runs the Gateshead Fertility Centre, one of the top ten IVF clinics in the country.

43. Scotswood Bridge

The current Scotswood Bridge over the Tyne is actually the second bridge to bear the name. The first was the Old Scotswood Bridge, or 'the Chain Bridge' as it was known locally, and it was a suspension toll bridge over the River Tyne linking the west end of Newcastle on the north bank of the river with Blaydon on the south bank. It had two stone towers from which the deck formed the road, and was suspended by wrought-iron chains.

In 1829 building of the bridge designed by John Green began. Two years later it was complete, opening on 16 April 1831 to the great excitement of the locals. A grand opening ceremony was held, with dignitaries forming a procession from the Assembly Rooms at Newcastle along the Scotswood Road and over the new bridge into Blaydon, on to Swalwell, and back over the bridge into Newcastle.

The demolition of the Scotswood Chain Bridge around 1967. (Photo by T. J. Ermel, courtesy of Gateshead Libraries)

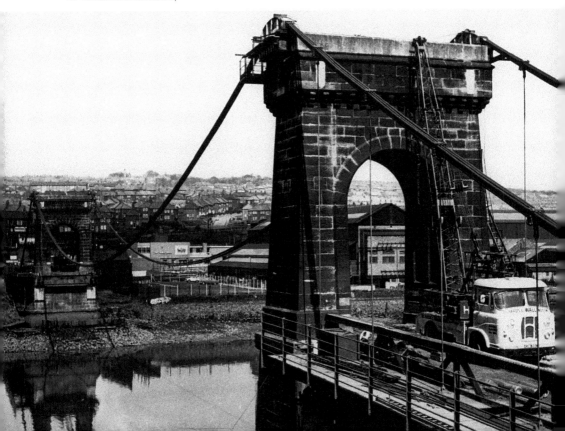

Above: The Scotswood
Bridge.

Right: It might not be
as iconic as some of the
other bridges over the
Tyne; however the bridge
serves millions of vehicles
each year.

In 1905 the bridge was bought by the Newcastle Corporation, and by 1907 there was no longer a toll to cross.

In 1931, the centenary year of the bridge, and with cars using the bridge rather than the horse and carts of the nineteenth century, there was need for it to be strengthened. The chains were changed to stronger steel wire ropes, and the decking itself reinforced. This allowed the weight limit to be raised from 6 tonnes to 10 tonnes. The bridge was also widened from 17 feet to 19.5 feet and two wooded footpaths added.

By 1941 it was decided that, despite the 1931 improvements, the existing Scotswood Bridge was impractical, as it was just too narrow for modern vehicles, and the repair costs had become unfeasible. Almost twenty years later, in 1960, permission was granted to demolish the bridge and build a replacement.

A new bridge was designed by Mott, Hay and Anderson, and construction commenced 92 metres west of the existing bridge on 18 September 1964. It was built by a consortium of Mitchell Construction and Kinnear Moody Group Ltd, and the steelwork was erected by Dorman Long. The existing bridge continued to operate during the construction of its replacement.

The new bridge was opened on 20 March 1967. Built to a new box girder design, this new bridge wasn't without its problems, having to undergo almost half a million pounds worth of improvements to strengthen it in 1971, only four years after it opened. Further work was carried out in 1979/80, and again in 1983, and it was closed completely for several months in 1990.

44. Trinity Square

When the Trinity Square shopping centre and multistorey car park was designed by Rodney Gordon of the Owen Luder Partnership in 1962, it was noted for its brutalist style, which

The 'Get Carter' car park in 1970. (Photo courtesy of Gateshead Libraries)

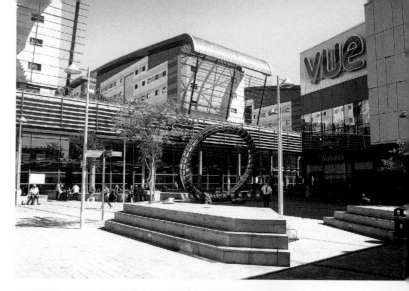

Trinity Square
in 2018.

Trinity Square
University
accommodation.

was considered cutting edge at the time. However by the time it opened in 1967, this style was considered outdated and unattractive, made, as it was, of concrete that weathered poorly.

Trinity Square dominated the skyline of Gateshead and became best known for featuring prominently in the 1971 Michael Caine film *Get Carter*, so became known as the 'Get Carter car park'.

The opening of the Gateshead Interchange in 1985, offering excellent bus and metro links, combined with the development of the Metro Centre, and the shopping on offer on Newcastle's Northumberland Street including the Eldon Square shopping centre, saw the car park at Trinity Square become largely redundant. In 1995 the upper floors of the car park had to be closed due to the structural integrity of the building worsening. The future looked bleak for the 'Get Carter car park', and in June 2007, despite strong opposition calling for it to be preserved as a Gateshead landmark, it was confirmed that Trinity Square would be demolished and rebuilt as a new town centre shopping complex. Pieces of concrete were sold by Gateshead Council, in commemorative tins, for £5.

In March 2013 the £150 million Trinity Square opened boasting a seven-screen cinema complex, a Tesco Extra store, and 240,000 square feet of retail and leisure space including shops such as Boots and Sports Direct, and bars and restaurants including Nandos. It also includes office accommodation, and student accommodation for Northumbria University.

Over 5 million people have visited Trinity Square since it opened. The *Halo* sculpture in the centre of the square was added in February 2014, and is a stainless steel structure created by north-east artist Steve Newby.

45. Gateshead International Stadium

On 30 August 1930, Redheugh Park, a new ground for the newly formed Gateshead AFC, was officially opened. A total of 15,545 spectators turned up to watch Gateshead AFC play their first ever Football League game, winning 2-1 against Doncaster Rovers.

By the end of the 1960s the ground had fallen into disrepair, and in the 1971/72 season there was a fire at the ground. A lack of funds left the club with no choice but to abandon Redheugh Park and move into the Gateshead Youth Stadium on the A184 Felling Bypass.

Shortly after the club's move, Redheugh Park, falling apart and infested with weeds and dilapidated stands, was demolished.

Gateshead AFC didn't fare too well at their new home, and in August 1973, having resigned from the Midland League, they went into liquidation.

Alternative Gateshead teams came and went over the next four years, and in 1977 Gateshead were reborn as Gateshead FC. The club joined the Northern Premier League and returned to the Youth Stadium, which by now had improved and expanded, and was now named Gateshead International Stadium.

The club has gone from strength to strength in the years that have followed, and in the 2013/14 season they made it to the Conference Premier play-off final at Wembley – the winner of the game would join the Football League. Gateshead lost a close game 2-1 to Cambridge United.

Gateshead International Stadium in 2018.

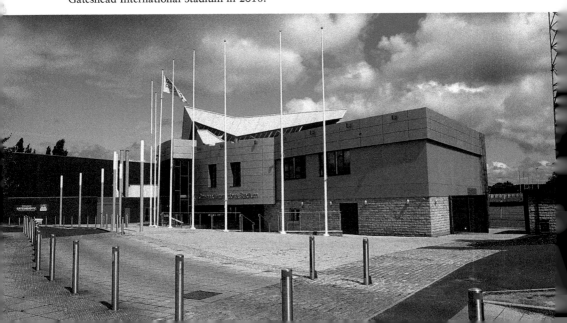

Above: The pitch and stands.

Right: Home to Gateshead FC since 1977.

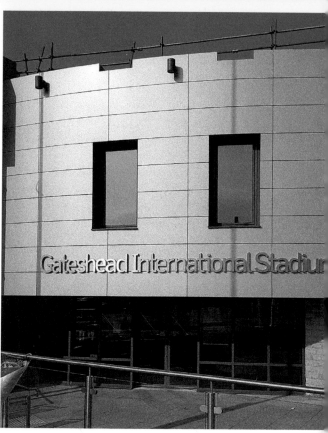

Plans for a new 7,856-capacity stadium for the club were unveiled in October 2009, to be built in the town centre opposite the Gateshead Civic Centre on the site of the former North Durham Cricket and Rugby Club. However, after the failure of England's bids to host the World Cup in 2018 or 2022, plans for the stadium, which would have acted as a training base for teams playing at nearby St James' Park, were put on hold indefinitely. The Heed Army still follow their team loyally at their home of Gateshead International Stadium.

46. intu Metrocentre

The intu Metrocentre was built upon waste ground that had been an ash dump for a power station on the banks of the Tyne in Dunston. It was bought for around £100,000 in the early 1970s. The ambitious scheme to construct the Metrocentre was overseen by property developer and later Newcastle United owner John Hall (of Cameron Hall Developments), later to become Sir John Hall, and the finance came from the Church Commissioners of England.

The £150 million centre opened in two phases. The Red Mall opened on 28 April 1986 and featured a large Carrefour supermarket, which later became Gateway and subsequently Asda. At the time John Hall said, 'What you see is just one-tenth of what we have in store for the future. It is one of the proudest days of my life.'

The official opening was on 14 October 1986. The Metrocentre, the original mega mall, the size of which had never been seen before, opened to great excitement and curiosity. It was the 'largest shopping and leisure complex in Europe'.

Reflecting its Church of England origins, Metrocentre is one of the few European shopping centres to have its own resident full-time chaplain. Services are held on special occasions such as Remembrance Sunday and Christmas.

The red mall was the first to open.

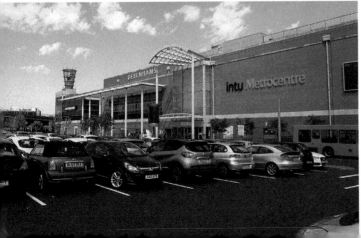

The signage for the intu Metrocentre.

Over 2.5 million shoppers visit the Metrocentre each year.

In 1988 Metroland opened at a cost of £20 million in the Yellow Mall, Europe's largest indoor amusement park. It included a roller coaster, pirate ship and Ferris wheel. Metroland closed in 2008 despite strong local opposition and a petition including 4,000 signatures. The closure made way for a redevelopment of the Yellow Mall, which now includes a new Odeon cinema with an IMAX screen.

Today the recently rebranded intu Metrocentre has undertaken countless changes and improvements since it opened almost thirty years ago. Since it opened back in 1986 over half a billion shoppers have visited, and it now boasts over 340 stores populating the 1.9 million square feet of shopping and leisure space. Over 15,000 free car parking spaces, and excellent transport links facilitate over 2.5 million visitors to the MetroCentre each year. It was the largest shopping centre in the UK for over thirty years until March 2018 when the Westfield centre in London underwent a £600m extension.

47. The Angel of the North

The Angel of the North, made of 200 tonnes of steel and standing 65 feet high with a 175-foot wingspan, dominates the skyline for miles around. It was unveiled on 20 June 1998 at a 'Celebrating an Angel' day held by Gateshead Council. It was a free event and included an opportunity to see Angel artwork by local children, entertainment by local musicians and artists, and the auction of the 'Angel-sized' No. 9 Newcastle United football shirt which the Angel had been kitted out in prior to its official unveiling. The man behind the design of the Angel, Antony Gormley, was also in attendance.

The Angel of the North generated much controversy from the beginning, with the British press running many negative news articles including a 'Gateshead Stop the Statue' campaign. Local councillors and public figures were also very vocal in their opposition to the sculpture. The Angel was quickly nicknamed the 'Gateshead Flasher' by locals because of his outstretched arms.

Despite the original opposition to the Angel of the North, it has become a local landmark, recognised worldwide. It is often used to represent Tyneside alongside the Tyne Bridge and the Millennium Bridge, and the people of Gateshead are now proud of 'their' Angel of the North. In 2006 it was even chosen as part of a government-sponsored Culture Online project as one of twelve official 'Icons of England' alongside others such as Stonehenge, the FA Cup and the Routemaster double-decker bus.

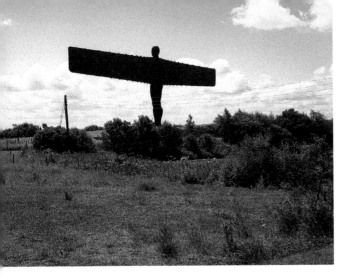

'The Gateshead Flasher'.

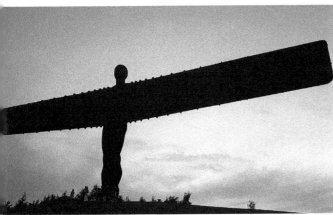

Left: A modern-day north-eastern landmark.

Below: This is the maquette used by Antony Gormley to cast the bronze replica of the Angel that is on display at Gateshead Civic Centre.

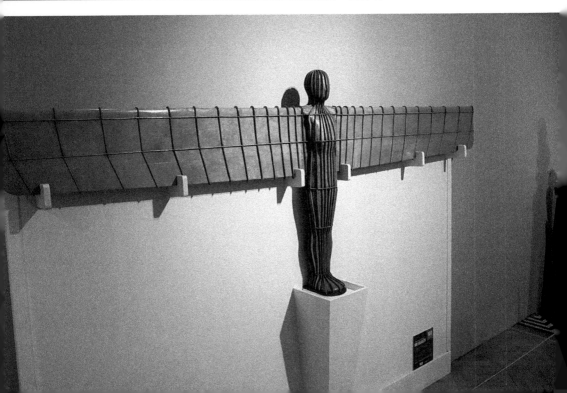

Today the Angel of the North, despite its lonely position on a hilltop overlooking the A1 on the southern edge of Low Fell, is one of the most viewed pieces of art in the world. It is seen by more than one person every second – around 90,000 every day, or 33 million every year. More than 150,000 visitors come to visit the Angel every year too.

48. Millennium Bridge

In 1996 Gateshead launched a competition to design a pedestrian and cycle bridge to span the River Tyne from the redeveloped waterfront of Gateshead Quays on the south bank, to the quayside of Newcastle upon Tyne on the north bank. This new bridge would complement the six bridges that currently crossed the river.

Gateshead residents voted for their favourite design from over 150 entries from leading architectural companies. The chosen design would go on to win architect Wilkinson Eyre and structural engineer Gifford & Partners multiple awards. The design was for a pedestrian and cycle bridge that would 'tilt' 40° to allow small ships and boats to pass underneath. It would even clean up its own litter as every time it opens anything lying on the deck of the bridge would roll into special traps at each end of the bridge.

The arch and the deck of the bridge was constructed by Watson Steel of Bolton. The mechanism that would allow the bridge to 'tilt' was made in Sheffield, while the frame was assembled just along the river at the Amec Yard at Wallsend.

The completed bridge was lifted into place in one piece on 20 November 2000 by Europe's largest floating crane, the Asian Hercules II.

On 28 June 2001 36,000 people lined the banks of the River Tyne to watch the completed Millennium Bridge tilt for the very first time. Its shape and appearance during this manoeuvre would quickly lead to it being nicknamed the 'Blinking Eye Bridge'. It

The Millennium Bridge at full tilt for a passing boat.

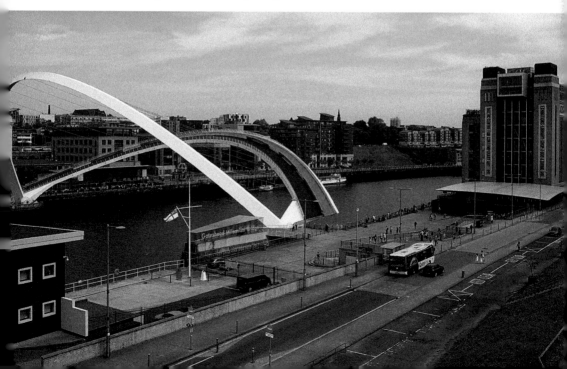

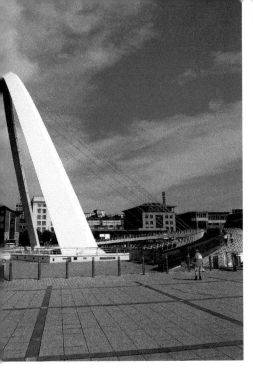

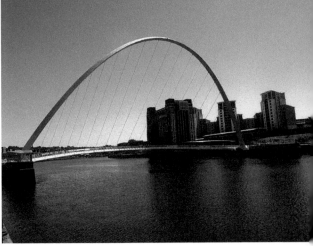

Above: Taken from the Newcastle side of the river, the BALTIC can be seen in the background.

Left: Visitors travel from all over the world to Gateshead to see the Millennium Bridge.

would officially open for public crossing on 17 September 2001, and was dedicated by Elizabeth II on 7 May 2002.

Despite the bridge being relatively new, it quickly became a Gateshead landmark, even featuring on a first-class stamp and a one pound coin. Its grace and revolutionary engineering have attracted visitors to Gateshead from all over the world.

The arch of the bridge lit up in a variety of changing colours, against the backdrop of the vibrant quays on both sides of the river. Is truly a sight to behold.

49. The Gateshead Hilton Hotel

The Hilton Hotel on Bottle Bank was opened in 2004, and is a wonderful hotel in a stunning location overlooking the Gateshead Quays. However, what those who stay there probably don't know is that what lies beneath the foundations of that luxury hotel is evidence of the very earliest beginnings of what we now know as Gateshead.

Compared to Newcastle across the Tyne, very little is known of Gateshead's beginnings. We know that there was the Roman fort at Newcastle at the site of the current Swing Bridge. For a long time it was speculated that there may too have been a small Roman settlement on the Gateshead side of the river. This was backed up by archaeological findings in the area – Roman coins in Church Street in 1790, and then coins found during roadworks on Bottle Bank in 1802. However, these isolated findings were not solid evidence of Roman occupation.

The big breakthrough and concrete proof of Romans being in Gateshead came between 1994 and 1997 when stratified Roman deposits were found when work was being carried out to properties near Bottle Bank, on the site now occupied by the Hilton Hotel. Archaeologists found a section of roadway, stone buildings, ditches and stone-lined cisterns. Remains of pottery indicate occupation from the early second century through to the fourth century.

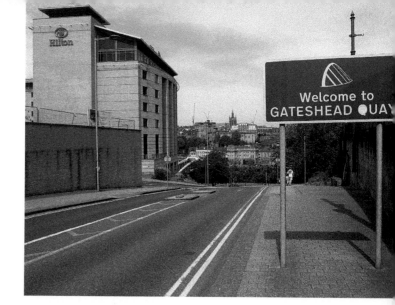

The Gateshead Hilton
Hotel on Bottle Bank.

50. Sage Gateshead

Sage Gateshead was designed to be a concert hall, conference venue and practice space for musicians of all abilities, spanning all genres. Planning for the centre began in the early 1990s, when the Royal Northern Sinfonia and Northern Arts decided to begin work on plans for a new concert hall.

Folkworks, a regional folk music development agency, came on board, and with that the guarantee that the needs of the region's traditional music would be catered for by this new venue. Practice spaces for professional musicians, students and amateurs were agreed to be a must-have for the proposed building.

A competition was launched in 1997 for architects to design a building that would capture all of the elements required, in a unique, eye-catching design. Over 100 architects showed an interest, with a shortlist of six interviewed. Foster and Partners were unanimously selected as the winner.

The planning and construction process cost over £70 million. The majority of the money needed was provided by grants from the National Lottery. The name of the buildings came

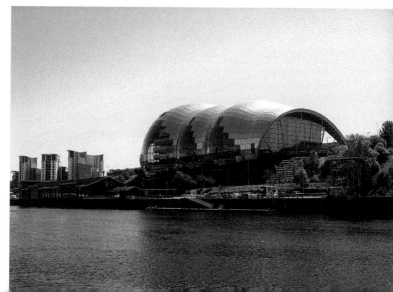

The stunning and
unique Sage Gateshead
on the bank of the
River Tyne.

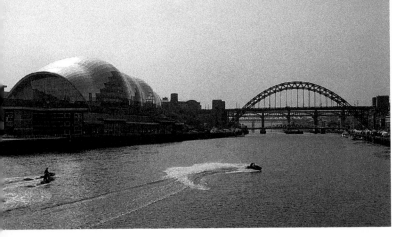

The Sage Gateshead with the Tyne Bridge visible.

Behind Sage Gateshead are a series of arches that are used for 'legal graffiti', operated as part of CoMusica's Urban Foundation Learning Programme.

from local business Sage Group, who paid a large sum of money to have the building named after it.

Sage Gateshead opened over the weekend of 17–19 December 2004 as a centre for musical education, performance and conferences. It consists of three separate performance spaces insulated from one another to prevent sound and vibration travelling between them. Hall One is a 1,700-seater venue modelled on the Musikverein in Vienna and designed to be acoustically perfect. Hall Two is a unique ten-sided performance space with a seating capacity of 450. And the third building is a smaller rehearsal and performance hall.

The eye-catching curved glass and steel building is part of the Gateshead Quays development, which also includes the Millennium Bridge and the BALTIC Centre for Contemporary Art.

Sage Gateshead has won many awards, including Local Authority Building of the Year in the 2005 British Construction Industry Awards, the RIBA Award for Inclusive Design, and the Journal North East Landmark of the Year award. Contrastingly in 2004 it won Private Eye's 'Hugh Casson' medal for the worst building of the year.